Through a Blue Lens

THE BROOKLYN DODGERS PHOTOGRAPHS
OF BARNEY STEIN, 1937–1957

Dennis D'Agostino and Bonnie Crosby

TRIUMPH
BOOKS

To Bob —
Enjoy a bit of my "Bums" lore they were the greatest!
Best regards —
Bonnie (Stein) Crosby
8/30/07

Library of Congress Cataloging-in-Publication Data
Stein, Barney.
 Through a blue lens : the Brooklyn Dodgers photographs of Barney Stein, 1937–1957 / Dennis D'Agostino and Bonnie Crosby.
 p. cm.
 ISBN 978-1-57243-952-8
 1. Brooklyn Dodgers (Baseball team)—History—Pictorial works. 2. Brooklyn Dodgers (Baseball team)—History. 3. Stein, Barney. I. D'Agostino, Dennis. II. Crosby, Bonnie, 1940– III. Title.

 GV875.B7 S84 2007
 796.357'640974723—dc22

 2006038072

This book is available in quantity at special discounts for your group or organization. For further information, contact:

Triumph Books
542 South Dearborn Street
Suite 750
Chicago, Illinois 60605
(312) 939-3330
Fax (312) 663-3557

Printed in U.S.A.
ISBN: 978-1-57243-952-8
Design by Wagner/Donovan Design
All photos courtesy of The Barney Stein Photo Collection, LLC © 2005

To Steve, my loving husband and teammate, and to Barney's progeny: Harriet, Adam, Nina, Gifford, Maxwell, and Finnian —B.S.C.

As always, for my family: for Helene, and Jeanne and Freddie, and Emilie and Charlotte…and most of all for Mom and Dad, for all the times they would drive along Bedford Avenue, point to the apartment building, and tell me all the stories of what used to be. I hope I got it right. —D.D.

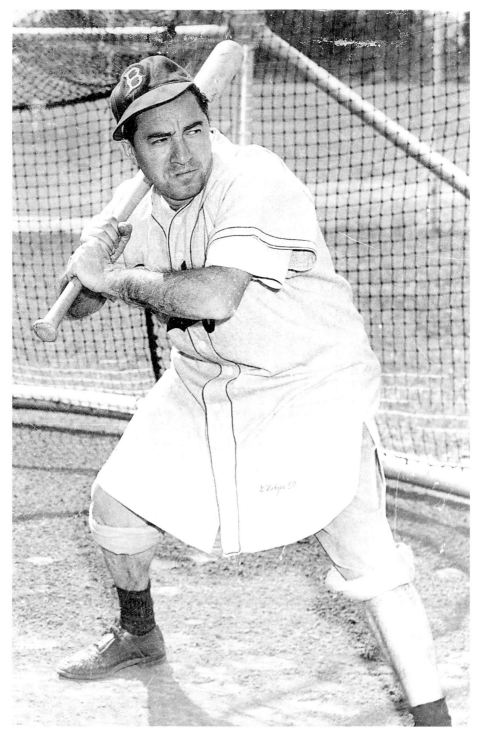

Barney Stein, sans camera, taking his cuts in spring training.

CONTENTS

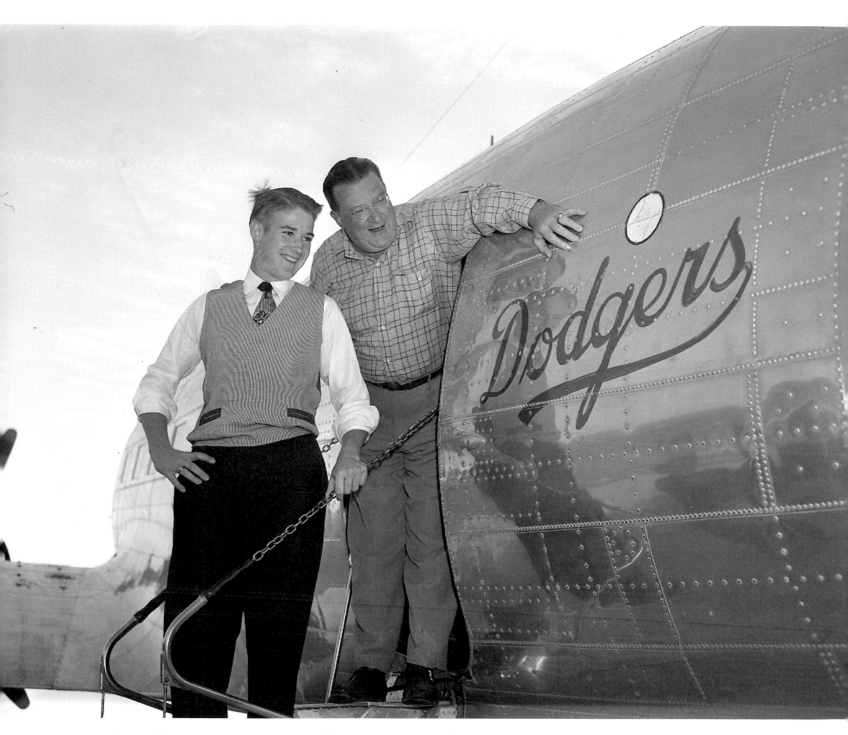

Peter O'Malley (left) and father Walter admire the Dodgers' team-owned DC-3, circa 1952.

FOREWORD

Barney Stein had the respect and admiration of everyone in the Dodgers organization. His keen eye for a picture enabled him to capture many memorable moments in Dodgers history. I am very happy that his family has decided to publish a collection of his award-winning photos.

Barney's respect for baseball, his sense of humor, and his engaging personality helped him capture historically significant events. All those who followed the Dodgers from 1937 through 1957 will thoroughly enjoy this book.

—*Peter O'Malley*
President, Los Angeles Dodgers, 1970–1998

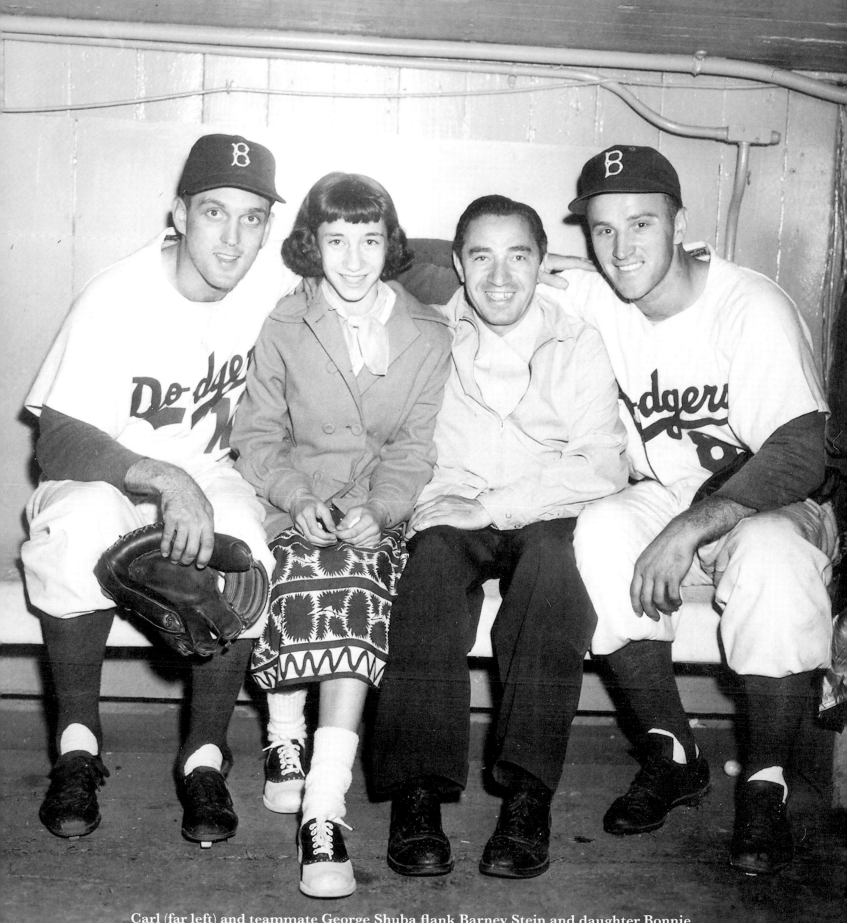

Carl (far left) and teammate George Shuba flank Barney Stein and daughter Bonnie.

FOREWORD

During the 1940s and '50s at Ebbets Field, there was a historic and legendary baseball team—the Brooklyn Dodgers—accompanied by a cadre of supporting characters. Among them was a small, wiry, and unassuming man named Barney Stein.

And of all the supporting cast—writers, broadcasters, ground crew, special cops, ushers, ticket-takers, etc.—no one placed into the historical record a more lasting documentation of "the Boys of Summer" than Barney Stein, through his world-class photographs.

Barney's quiet approach and quality of work as the Dodgers team photographer gained him great respect from the players. Jackie Robinson, Pee Wee Reese, Duke Snider, Roy Campanella—all future Hall of Famers—and all the rest of us considered him practically a part of our team. Barney not only took action shots on the field and in the clubhouse, but he was also with us on off-day picnics and often set up family photos in our homes in Brooklyn. He was one of us.

It was an era when three outstanding major league teams—the Yankees, Dodgers, and Giants—competed in New York. Barney had his own competitors. A contemporary of other outstanding sports photographers such as Herbie Scharfman and Ozzie Sweet, Barney still took home numerous honors and awards.

This book captures countless special moments in a baseball era many say was the golden age of the game. You'll not only see and enjoy Barney's work, but as you view these photos, you'll feel the emotions of the times.

Today, we Brooklyn Dodgers do fantasy camps at Dodgertown in Vero Beach. Well, when someone lines us up for a picture, and they flash the picture, one of us old Dodgers always says, "*Uno más!*" That was Barney's line. He always wanted to take one more. "*Uno más! Uno más!*" That was his trademark.

So as you finish your first reading of this book, you're almost certain to flip back to page one and echo Barney's trademark, "*Uno más!*" One more time!

—*Carl Erskine*

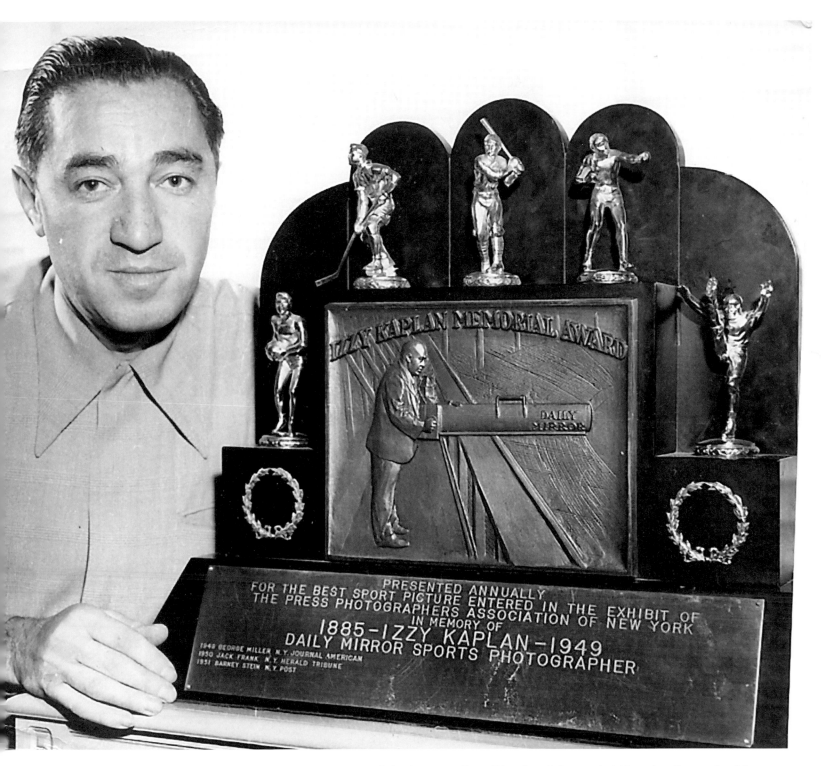

Barney Stein at the height of his career, with the 1951 Izzy Kaplan Memorial Trophy from the New York Press Photographers Association.

PREFACE

Believe it or not, this book was born out of my belief that the *last* thing this world needed was another book on the Brooklyn Dodgers.

No team in American sports has been more written about, analyzed, documented, celebrated, mourned, or eulogized. The five decades that followed the team's departure for Los Angeles have brought wave after wave of Brooklyn books, movies, and documentaries…some wonderful, some historic, many useful, and some just plain bad.

So it wasn't much of a stretch to think that every possible facet of the Dodgers' history in Brooklyn had been unearthed, hashed over, and then *re*-hashed over.

Everyone who grew up in Brooklyn in the '40s and '50s, it seems, has written a book—or at least been quoted—about growing up in Brooklyn in the '40s and '50s. After 50 years, how many different ways are left to describe Sandy Amoros's catch? Is there *anyone* left who hasn't talked about walking down the street in Flatbush and catching Red Barber's voice coming out of every window? How many times does Ralph Branca have to answer *another* question about Bobby Thomson?

Half a century after their final game, it seemed that there really wasn't anything to say or write about the Brooklyn Dodgers that hadn't already been said or written.

But a little green book on my shelf kept telling me otherwise.

It was a worn paperback that I had picked up for about $5 more than two decades ago at a church-basement baseball card show in Manhattan. Its title—*The Rhubarb Patch*—was a nod to Barber's homespun descriptions of life at Ebbets Field. Its subtitle, "The Story of the Modern Brooklyn Dodgers," carried the Dodgers story up to the "modern" era of 1954.

And inside, over 121 pages, was handiwork of a remarkable little man named Barney Stein.

On yellowing paper were photographs that still amazed. Dolph Camilli sliding home, spikes high. A 6'6" first baseman named "High" Howie Schultz on skis at Bear Mountain. Jackie Robinson on the bench for the Montreal Royals. Gil Hodges chasing an errant dog along the first-base line. Gladys Goodding at the organ. Branca weeping on the clubhouse steps after the Thomson homer.

As the official Dodgers team photographer from 1937 through 1957, Barney Stein had access that no other media member had. His photographs—seen in newspapers, magazines, and club publications such as the Dodgers' annual yearbooks—reflected that access, as well as the high regard the Dodgers organization had for him.

When the Dodgers moved west following the 1957 season, Barney did not accompany them. With a wife, two daughters, and a career in news photography firmly grounded on the streets of New York, Barney's heart, and future, lay in the Big Apple and not in Los Angeles.

So the Dodgers left and Barney stayed behind… along with, eventually, the body of his Dodgers work.

I knew it was out there, someplace. I had read, and nearly memorized, *The Rhubarb Patch*. I had seen snippets of Barney's work—a print here, a photo there—published within the flood of Brooklyn Dodgers books. I knew there was a daughter, Bonnie Crosby, who had saved and catalogued her father's Dodgers work, which had been bequeathed to both her and her sister Harriet. Bringing the Dodgers photos of Barney Stein back to light, finally, after half a century could perhaps be the way to present the Dodgers of Brooklyn in a way they had never been presented before.

Finding Bonnie was not an easy task. Barney passed away in 1993, and old photo and media contacts I had in New York could not come up with her whereabouts. Someone told me she had become a dancer and had drifted away from sports (but, thankfully, not from her father's work).

Finally, not long after I had moved west myself, I found the website that Bonnie had started to document her father's work, not only with the Dodgers but as an ace news photographer as well. There was an email address listed, and several weeks later a package arrived from Bonnie containing stacks of small, low-resolution scans of her father's surviving work.

When I opened the package, I was nearly overwhelmed. Here among the muddy, tiny images were action shots, naturally. But there was also Gil Hodges and Carl Furillo eating off paper plates at their lockers, and a young Vin Scully in penny loafers, and Jackie Robinson and Pee Wee Reese donning chef's hats, and Leo Durocher clowning with Milton Berle…and the famous Branca photo. There were views from *everywhere* inside Ebbets Field: the clubhouse, the dugout, the executive box, the rotunda…and shot after shot taken on that final, fateful night in September 1957.

We'd seen plenty of the Brooklyn Dodgers. But since the vast majority of Barney Stein's work had stayed hidden since the move west, they had *never* been seen like this. At least not for the last 50 years.

✳

Bonnie and I agreed that the way to truly bring Barney's photos back to life would be to seek out the surviving members of the old Dodgers family, present them with as many of the photos as we could (especially the offbeat ones), and get their reactions to images they hadn't seen in half a century, or perhaps had never seen at all. The focus, then, is on the photos and the events

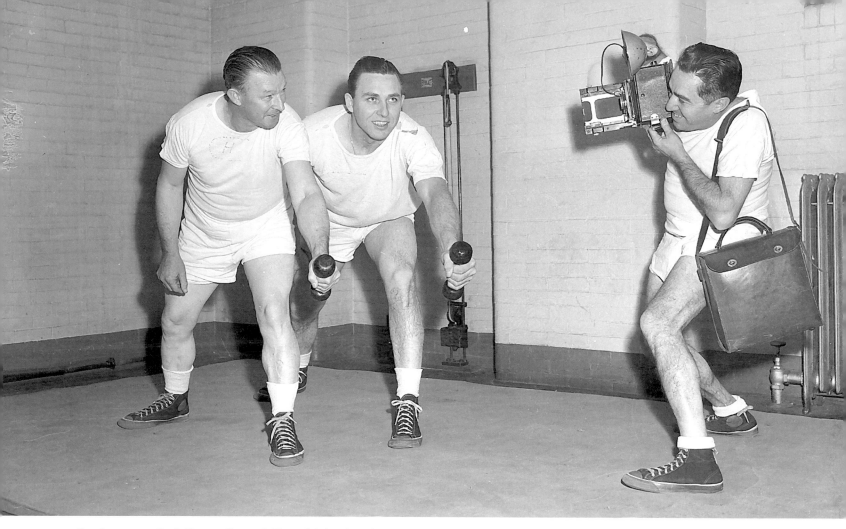

In the gym (holding a Speed Graphic) with Chuck Dressen and Gil Hodges.

surrounding them, not on yet another game-by-game reminiscence of the 1955 World Series.

The voices you'll hear are those of six legendary players of the Brooklyn era—Hall of Famer Duke Snider; 1956 Cy Young Award–winner and National League MVP Don Newcombe; ace pitchers Carl Erskine, Ralph Branca, Clem Labine, and '55 World Series hero Johnny Podres—along with longtime Dodgers executive Buzzie Bavasi, Gil Hodges's widow, Joan, and Hall of Fame announcer Vin Scully. In addition, quotes from Barney's unpublished memoirs, also preserved by Bonnie, are included as well.

Most of the old Dodgers, of course, hadn't seen Bonnie since she was a teenager during the Brooklyn days. And many didn't know me from any of the other eager historians who had pestered them over the years. But with all of them, the first mention of the name "Barney Stein" brought smiles and laughter, and unleashed a flood of memories.

No one at Ebbets Field, I soon learned, was held in greater esteem.

"When Barney wanted a picture, he got it! That I'd have to say," said Labine over the phone from Rhode Island, six months before his death in March 2007. "He wasn't the biggest man in the world, but I'll tell you one thing…he could get around!

"He was not abusive, not about anything. He was as gentlemanly as he could be, and I'll tell you one thing…as

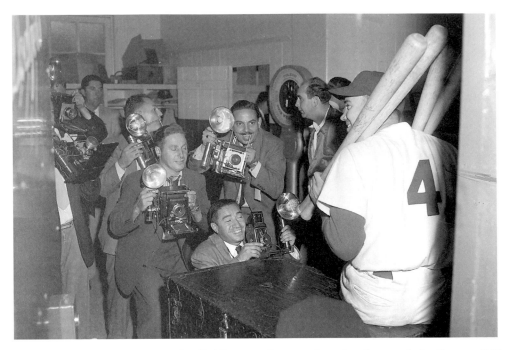

A grinning Barney (bottom, center)—Rolleiflex at the ready—in the mob in front of Duke Snider during the 1952 World Series. When shown this photo, Snider said, "In this picture, there's a bunch of photographers there, so I guess Barney wasn't completely in charge, for once."

gentlemanly as he was, he still got his pictures. He fought for them. But we were so mellow with him, and he with us. Anything you ever wanted from him, you could have. If you wanted a special picture, he'd do it for you."

"Barney had a favorite saying: '*Uno más!*'" remembered Newcombe, now a West Coast fixture as the Dodgers' director of community relations. "[He'd say it] every time he took a picture of us, especially when we were taking the team photos. And we had some guys, and I was one of them, who would always give Barney hell about taking *uno más*. 'What the hell you talkin' about, Stein, you've got one!' *Uno más*. And we'd kid him a lot about it because Barney was such a nice man. He always had a smile on his face."

"What I remember about Barney is that he was a really good guy, always smiling," said Branca. "Very efficient. A very small guy, not very big. Very friendly. His wife, Ruth, was very charming as well. A very pleasant guy."

"He didn't push himself on us, and he was very comfortable to be around," added Snider. "Barney was always looking for the little extra-special photograph that not too many other guys would think about."

"Barney always had that smile, and when he took pictures it was always, 'One more!' or '*Uno más!*' Well, he had to make some money, right?" laughed Podres from his home in upstate New York. "And you know what's really something? All the players would get on him, and it didn't bother him, and the players just stood there and waited until Barney took another one! Barney had 'em, boy. He had that smile that said, 'I *know* what I'm doing.' He was definitely loved."

Several Dodgers remembered the laid-back Barney in tandem—and in distinct contrast—with one of his fellow photographers, the outgoing and loquacious Herbie Scharfman of International News Service.

"Two of the opposites! Totally opposite!" roared Bavasi, hale and hearty at 92. "[Herbie] enjoyed waking up in the morning. He was a pistol, just the opposite of Barney. With Barney, you never knew he was around. You'd sit with Barney for 20 minutes and he'd never say a word, but he listened very carefully.

"Never abused [his access], and he was always welcome. The door was always open to Barney. You couldn't say that for the others, but always for Barney."

Even Bonnie, long past her days as an Ebbets Field fixture, was fondly remembered.

"Oh, she was so full of life," exclaimed Joan Hodges. "I would hold my arms out and she would run into my arms and snuggle up against me!"

Besides his sincerity and honesty, I soon learned that another trait that endeared Barney to the Dodgers was his attitude toward the team's pioneering African American players. Barney made no secret of the fact that his all-time favorite Dodger was Jackie Robinson, and over the years he and his wife, Ruth, became extremely close to Jackie and his wife, Rachel. As a Russian Jew who immigrated to America at the age of six months, Barney was particularly sympathetic and encouraging toward them.

"I remember [the relationship] between Barney and Jackie because of who Barney was and what his ethnic background was, and what we were going through," a reflective Newcombe told me. "Jackie never forgot it. I think that went a long way toward helping both of us understand where we were from and what we were going through. Jackie appreciated it, and I think so did Barney. They understood what we were involved in.

"Same thing with Sandy Koufax. Sandy was a Jew and we were black, and Sandy caught hell from some of the players on our club because he sat on the bench and couldn't perform because he was a bonus baby and wild as hell. Some of the guys had to go back to the minors because we had to keep Sandy on the team, and Sandy never forgot that. He still shakes my hand about it and says how much we took care of him."

✳

Barney Stein was a top nutter.

A *what?*

"A top nutter is a crazy guy!" Stein said with a laugh in a 1967 radio interview.

Barney was referring to some of the things he'd do to get that one-of-a-kind news picture, from climbing the old mooring mast of the Empire State Building to rushing to a blaze or flood in full fireman regalia. For his Dodgers assignments, things were a little calmer. In a 1950s magazine article, he shared some of his game-day secrets (Warning—You won't find the word "digital" anywhere in here!):

"The mechanics of making baseball pictures are fairly simple," he wrote, "I use a telephoto lens on my 4x5 Graphlex because we work in the photographers'

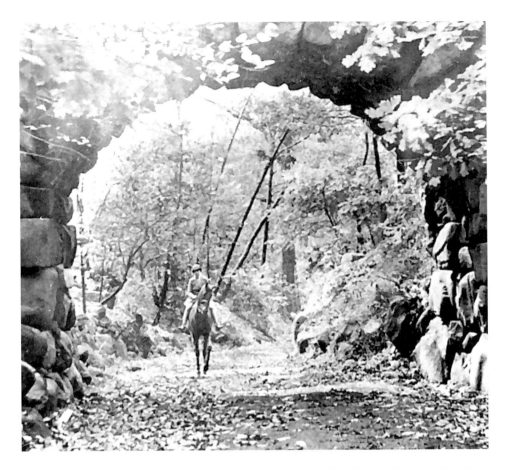

**The shot that started Barney's career with the Dodgers: Dearie Mulvey
on horseback in Prospect Park.**

box at Ebbets Field. I use Sport Film because it's very fast, and I try to shoot as fast as possible according to lighting conditions, in order to stop action. That means shooting from 1/200 to 1/1,000 of a second, depending on whether or not the sun is on the bases.

"At night games, flash is unnecessary because of the intense lights on the playing field. To stop action under these lights, I shoot at 1/135 to 1/300 of a second. These figures sound contradictory, but the direction of the action must be taken into account. If the action is coming toward the camera, you can stop it at a slower speed than if the action is at right angles to the camera. From the photographer's box, the action usually is at an oblique angle, so there's only a slight blur if you shoot at less than 1/200 of a second in a night game."

Incredibly, Barney almost never used an exposure meter. "Most photographers use them. I don't," he said in 1967. "I guess I should, but I know my exposures so well, it's like force of habit. I should get one for color, but we have no use for color. It's just force of habit, it's just like getting up at a certain time each morning. I can judge…with my eye and my head.

"A photographer should know how to do darkroom work, to be able to develop and print."

By the time the top nutter ended his career, he had left behind a library of Dodgers photos. Bonnie, of course, has retained several hundred images, a sizeable amount but still—and unfortunately—only a mere fraction of her father's work. Many Barney prints still linger in the team publicity files at Dodger Stadium, as well as at the Baseball Hall of Fame. Still others are in the private collections of the old Dodgers. Many are possibly lost forever. During one phone conversation, Buzzie Bavasi mentioned that on his desk at that moment was the photo album that Barney had made for him (and all the executives) following the '55 Series. "It had about 100 photos in it," he told me. "Now it's down to about 65 because I sent pictures out to people who wanted to use them, and I never got them back!"

Many of the Dodgers photos that Bonnie had preserved were captioned either incorrectly or not at all, forcing us to be detectives as well as historians. This was one of the most enjoyable aspects of the work…tracking down who's who and uncovering the exact circumstances behind each photo. One

shot, from March 1957, was simply labeled "Emmett Kelly as The Bum, sitting on bench in spring training." Accompanying Kelly were, unmistakably, Walter O'Malley and Duke Snider. Completely ignored were two other gentlemen wearing business suits: Kenneth Hahn and Norris Poulson, two of the key figures who would help engineer the Dodgers' move west just seven months later.

As you flip through this book, please be aware that it certainly is not intended to be a definitive history of the Brooklyn Dodgers or yet another "Dodgers Encyclopedia." Far from it. Please try to imagine it, instead, as a family album…of one of the most famous families in American history. Hopefully the images and the voices we've captured here will give you a vivid look at how it was, exactly 50 years after the final season in Brooklyn. It will also, I hope, bring you a little closer to knowing the man who captured it all.

So maybe I was wrong. Maybe we *did* need one more book on the Brooklyn Dodgers.

I hope you'll think this is the one.

—*Dennis D'Agostino*

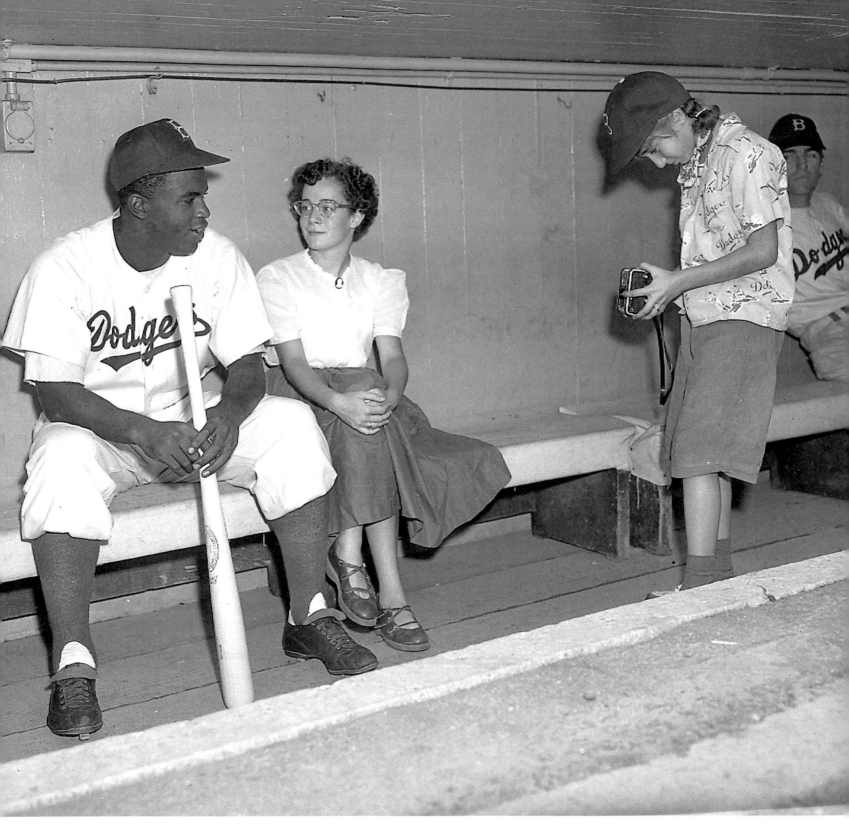

With her Brownie camera, Bonnie Stein snaps her sister Harriet and Jackie Robinson.

INTRODUCTION

One of the conditions I set forth to Dennis when he contacted me about collaborating on a book celebrating my father and his Brooklyn Dodgers photos was that my coauthor be Brooklyn born and bred. During subsequent conversations and email exchanges, it was clear that he had to have breathed the same Brooklyn air as the Dodgers. His knowledge of, and excitement for, the history and spirit of the team was instinctual. I forgave him for now living in California as my father had forgiven Walter O'Malley for moving the Bums west so many years ago.

The words *retirement*, *sit still*, and *relax* were not in Barney Stein's vocabulary. For as long as I can remember, my father was the embodiment of perpetual motion. Everyone should have half as much fun with his or her job as Barney did with his. He was just a bit over 5' tall, and he moved fast, beginning with his days as a medal-winning sprinter at Stuyvesant High School.

That characteristic served him well in his chosen profession. Both spot news and sports photography require a keen eye, knowledge of the camera's technical possibilities, an understanding of the situation, and exquisite timing. Dad was a master of all.

His friendly demeanor and compassion for the subjects of his images provided many opportunities for him to shoot when it was off limits for others. Sometimes he got into hot water by being so friendly, but he was able to extricate himself from embarrassing situations using charm and humor. He was the genuine article; there was nothing artificial about him.

Barney was a risk taker. He climbed the Empire State Building's mooring mast and scaled a cable on the Triborough Bridge while it was under construction. He would do almost anything for a great photo, especially when competing with other tabloid papers in New York.

He took many fine photos, but his passion was shooting the Brooklyn Dodgers.

Barney worked his way into the field of photography in the 1920s. He answered an ad for a job as a delivery boy for a photo lab. One day the photographer on duty didn't show up, and Dad was asked if he knew how to operate a camera. Instinctively he said "yes," and the rest is history.

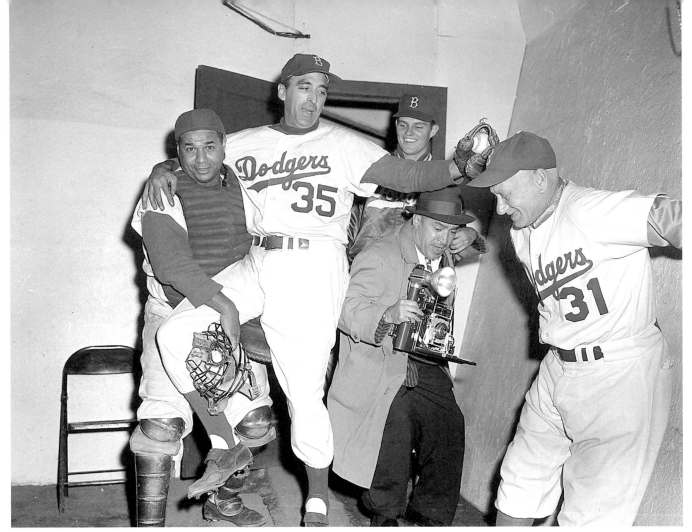

Wedging his way into the TV interview room following Sal Maglie's 1956 no-hitter, Barney gets caught amid Roy Campanella (left), Maglie (No. 35), Don Drysdale (rear), and coach Jake Pitler. He's holding a Speed Graphic with a strobe light.

By the '30s he was a staff photographer for the *Brooklyn Times Union*. When that paper folded in 1937, he joined the staff of the *New York Post*, and for the following four decades was one of the paper's most valued staff photographers.

But it was through a chance encounter with Dearie McKeever Mulvey that he entered the world of the Dodgers.

When my father was in his last years and in poor health, I asked him to delve into his long-term memory and write down, with the help of his trusty Royal typewriter, the many experiences of his career. So I'll let

Barney tell this story, the story of the American Dream for a young man born in Russia in 1908, who came to the United States when he was six months old.

"I was the staff photographer at the *Brooklyn Times Union*, and I was told by my city editor, one I. George Quint, to go around Prospect Park to bring back some news and feature photographs," my father wrote. "I came across a horseback rider about to go under a stone arch. The rider was a woman who stopped me and asked who I was, then asked me what I wanted for the photo, as she was very much interested in it. I hemmed a bit and then replied, 'Lady, I don't know who you are, but

you made such a beautiful picture going through the arch that I want to give it to you as my gift.' She was flabbergasted by my generosity and asked me to bring the photograph to her home. Little did I know that meeting would change the course of my life.

"When I arrived at her home the next day with the photograph, I learned she was the wife of James Mulvey, a vice president of the Brooklyn Dodgers, as well as the daughter of Steve McKeever, the team's president. 'Wow,' I said to myself, 'what did I fall into?' Her name was Dearie Mulvey, and she proudly introduced me to her husband and her father, 'the Jedge,' as he was fondly known."

The meeting with the Mulveys and "the Jedge" led to an invitation for Barney to cover spring training in Clearwater, Florida, in 1937.

"I called my wife, Ruth, who was 'fragrant' with our first child, and she said, 'I'm packed, let's go,'" Dad wrote. "It was a different and wonderful world for me, to be among experienced sports photographers covering the Dodgers for their papers and syndicates. Luckily for me, they took a liking to this short guy, and I was on my way."

And thus began my father's two decades–long career as the official team photographer for the Brooklyn Dodgers.

Of course, his day job was as a staff photographer for the *Post*. From 1937 through 1957, he worked from 5:30 AM until noon for the *Post* and then switched over to his Dodgers duties in the afternoon and into the evening.

"During baseball season, everyone knew that when Barney's shift was over he was out the door and on his way to Ebbets Field," says Arty Pomerantz, Dad's colleague at the *Post*. "Barney's Dodger photos were made during his off-time from the *Post*, but [he] shared his images with the *Post* without receiving compensation." Things were more relaxed, and there was more passion than money involved. Those were the days!

Usually Dad catnapped before heading to Ebbets Field for a game. On non-game days, our family dinner was at 5:00 PM, and my sister, Harriet, and I always asked the same question: "What did you do today?" We would hear stories about Cardinal Spellman, politicians, movie stars, and gangsters—of events both happy and tragic. I remember his stories about "cheesecake," which described the slightly risqué photos of starlets and Hollywood stars. Sometimes he was too embarrassed to talk about them.

But there was nothing embarrassing about his Dodgers work. Barney's photos portray the team's character and the soul of Ebbets Field and have helped to keep the Dodgers so real in memory a half-century after their departure from Brooklyn.

My dad always made his Dodgers work a family affair. Prior to buying our first car, we would ride the subway to the Prospect Park station and walk to Ebbets Field. During games, we sat in the photographers' box, walking along a narrow gangplank suspended high above the box seats between home plate and first base. At times my mother Ruthie sat with the players' wives,

"What a way to earn a living!" Barney with Dodgers wives (left to right) Dottie Reese, Evit Bavasi, Kay O'Malley, Peg Thompson, Mae Smith, and Lela Alston.

and lunch often meant a trip upstairs to the pressroom for a ham sandwich and a Coke. I would wear my Brooklyn Dodgers shirt and pedal pushers and carry my Brownie camera.

Sometimes we would assist Dad in his work, holding his camera bag or strobe gun. Barney began using a Speed Graphic camera with a telephoto lens (it weighed a ton), which produced 4x5-inch negatives from the cumbersome film packs. In later years he switched to the Rolleiflex and finally to a Nikon 35mm. He also loved using a Veri-Wide camera with a 180-degree lens.

There were even times when he enlisted us as co-photographers. Here's a story Dad typed out on the old Royal, about Carl Erskine's 1952 no-hitter against Chicago:

"I had brought my ever-loving wife, Ruth, who always brought me chopped liver sandwiches to the ballpark," he wrote. "As the innings tolled away, the feeling of a no-hitter by Carl was evident, and

toward the seventh and eighth innings I was getting nervous.

"I had two cameras with me that day and gave one to Ruth, setting the camera for a jubilant crowd shot on the field in case of a no-hitter. My Ruthie was all thumbs with the camera, but she came through with flying colors! I went close to the Dodgers dugout to rush to the mound with hundreds of others in case Carl pitched the no-hitter—and did he ever come through! As I rushed into the dugout after getting my photos of Carl, I looked up to the photog's stand where my Ruthie was watching me, and she flashed me the okay sign that she made the shot I wanted. How's that for a husband-and-wife team?"

Each year for spring training, our entire family went to Dodgertown at Vero Beach for three weeks. Harriet and I took our school assignments with us, and we did our homework while sitting around the pool. Other children were there, too…Jackie and Rachel Robinson's Jackie Jr. and baby, Sharon; Pee Wee and Dottie Reese's daughter, Barbara; Duke and Bev Snider's son, Kevin; Gil and Joan Hodges's little Gilly; and Carl and Betty Erskine's boys, Gary and Danny. We ate in the cafeteria, drank freshly squeezed orange juice in the groves surrounding the camp, and slept in a room with government-issued cots. Needless to say, Dodgertown was not as posh as it is today!

We became friendly with so many of the Dodgers front-office officials, including the dashing traveling secretary, Lee Scott; business manager, Harold Parrott, and his gracious, Josie; and the hilarious, irreverent, and

loving press agent, Irving Rudd, and his wonderful wife, Gertrude.

Of course, there was also Walter O'Malley and his lovely wife, Kay. My father never said a bad word about Mr. O'Malley. After the Dodgers moved west, Dad went on with his life but did experience a period of depression as so many fans did. Years later, my dad would write: "O'Malley was the most understanding and helpful man we photogs have ever known, and I admired his gracious wife, Kay, and their most friendly children, Terry and Peter.

"I knew Mr. O'Malley when he was the attorney for the Dodgers and cherish the close association with him and Mrs. O'Malley. We still correspond, especially when it comes to St. Patrick's Day. I get a menu from Mr. O'Malley from Vero Beach, and he names the food to correspond with the club officials, press people, and players, and he fondly named one for me: 'Lobster à la Barney Stein.'

"I wouldn't trade anything for all the experiences and fun I've had with such a grand bunch of players and all the officials, especially Buzzie Bavasi and his beautiful wife, Evit, and Fresco Thompson and his smiling Peg, who always loaned us photogs her car when we needed it."

My father was equally fond of the legendary Branch Rickey, who took over as Dodgers president several years after my dad joined the team. "Branch Rickey was one of the grandest men I've known in baseball," my father wrote. "He treated me like a son.

"One summer day he invited me to his farm in Chestertown, Maryland. His whole family was gathered

for a day's outing, and Mr. Rickey wanted me to shoot candid pictures to be put into an album and to present one to each of his children. We had agreed on a price for five albums. I gave him six—one as a gift from me. Mr. Rickey was so thrilled with the many pictures I took that he gave me a signed blank check and told me to fill in any amount I desired. I told Mr. Rickey we agreed on a price, and I stuck to it."

My father reached the peak of his professional career in 1951, with his unforgettable photo of Ralph Branca in the Dodgers clubhouse at the Polo Grounds after Bobby Thomson's pennant-winning home run. That earned him one of the most prestigious awards in photography: the 1951 Izzy Kaplan Memorial Trophy from the New York Press Photographers Association, as well as first prize in the sports category at the association's annual exhibit. How fitting that just a few weeks after the Thomson homer, Barney was the photographer on duty at the wedding of Ralph Branca and Ann Mulvey…the daughter of Dearie and Jim, who had gotten him started with the Dodgers in the first place!

Three years later, my father and announcer Red Barber collaborated on *The Rhubarb Patch*, a book documenting Barney's Dodgers photos up to that point. Published by Simon and Schuster, the book kindled both my and Dennis's desire to see Dad's work celebrated in the new millennium.

Dad was a generous man and was always taking a friend's son or sons with him to Ebbets Field as assistants. The late American composer Morton Gould had two sons, and they were part of his entourage. Barney, who knew early on that his daughters were not too interested in baseball as they grew up—he had to wait for his grandchildren Adam, Nina, and Ford to rekindle the spirit—was happy to do this for his friends.

Dad's granddaughter Nina Kaplan carries on his journalism spirit. During her time at *The Palm Beach Post*, she wrote: "It's little surprise that he bought me my first camera: a Kodak pocket model, with a red button. Barney was always a proud critic. I remember his praise of the photos I shot at his 80th birthday celebration, and it was the photos of his induction ceremony into the Brooklyn Dodgers Hall of Fame that he waited to see before he passed away. I've learned not to feel like their arrival gave him license to give up; I'm simply glad that he saw them, and we could connect one final time.

"And I remember his contagious laughter. His laugh came from his belly, resounding through the room, his eyes atwinkle. When he laughed, he meant it. I still have his cards, letters—handwritten and typed—and they show a man of passion—for his work, for his family, and of course for the Brooklyn Dodgers. There are many ways I could describe Barney. Good-natured. Talented. Loving. Always loving, always loved."

Being a creative man, Barney continued to reinvent himself in the photographic community following the Dodgers' departure, an early retirement from the *Post*, and a move to Florida when health problems dictated he live in a warmer climate. When someone asked my mother how Barney was taking to his so-called retirement, she replied, "I never saw anyone rushing to

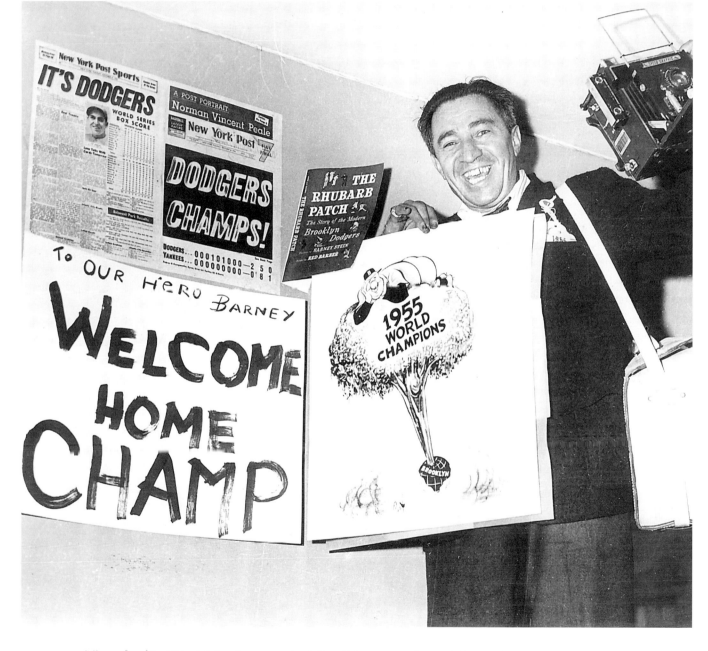

After the '55 World Series win, holding his trusty Speed Graphic and a copy of his
1951 book, *The Rhubarb Patch*.

do nothing as much as 'Top Nutter Barney Stein.'" In his later years, Barney, still faithful to the Dodgers, covered spring training at Vero Beach for several Florida newspapers, escorted around the complex by his old friends Peter O'Malley, Tommy Lasorda, and Billy DeLury.

Among Dad's closest friends were his fellow photographers, including Herbie Scharfman, Walter Kelleher, Harry Hirsch, and Bill Jacobellis. His dearest friends, fellow photographer Arty Pomerantz and Arty's wife, Ulla, hosted a surprise 80th birthday party that was attended by many of Dad's colleagues from the newspaper and sports worlds.

Barney was inducted into the Brooklyn Dodgers Hall of Fame in 1993. Too ill and frail to travel to Brooklyn from Florida, my sister Harriet accepted the honor on his behalf. He passed away later that year, on June 29, at age 84. Ruth passed away in 1999. They had been married for 62 wonderful years.

Discovering Barney's trove of negatives and prints following his death prompted me to put his work in order. Barney was of the old school of shoebox filing, prior to the advent of computer technology. With the help and guidance of several special individuals—especially my husband, Steve—I was able to produce a website for The Barney Stein Photo Collection, LLC (www.barneystein-photography.com) and preserve Barney's images, many of them never before published.

Then, in early 2005, I received an email from Dennis, who shared the same passion for bringing my father's Dodgers work to light again after half a century and who had the knowledge and insight to bring the dream to fruition. The book you are holding is the result.

Barney Stein is symbolic of the dedicated photographers whose work formed lasting pictorial histories of their generations. The photographs in this book are his legacy to his family and to all Brooklyn Dodgers fans of many generations. They are also a loving testament to a time, and a team, from the best father any two daughters could ever have.

—*Bonnie Stein Crosby*

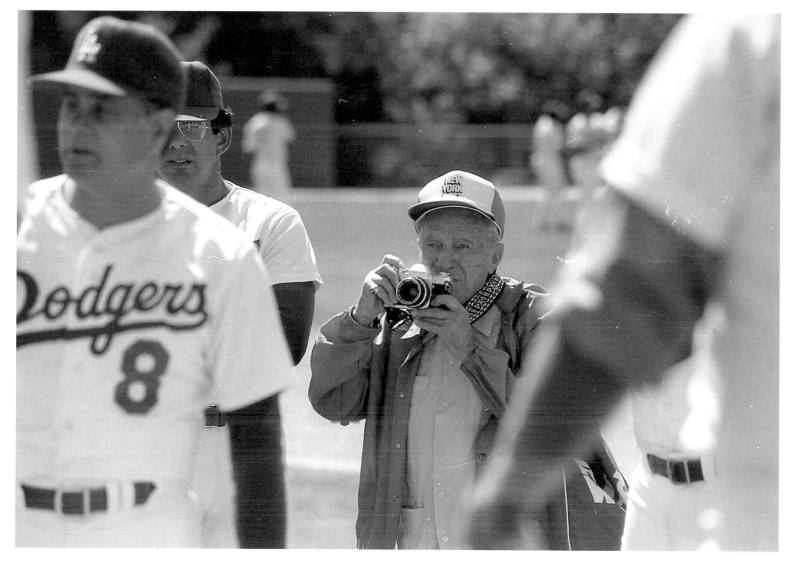

Still shooting at age 80; with the Dodgers in spring training, 1988. No. 8 is Coach Joe Amalfitano. *Photo by Joyce Mendelson.*

ONE

Faces of Joy,
Faces of Heartbreak

*T*heirs were some of the most recognizable faces in the land, the faces of Duke and Jackie and Pee Wee and Campy and Skoonj and Newk and Oisk.

Barney Stein captured the faces of the Brooklyn Dodgers with a unique brand of sensitivity, one that fit his own personality as a gentle, unassuming individual. When the Dodgers won, Barney captured all their revelry and noisy, heartfelt emotion. When they lost, he respected and shared in their grief, but his dogged professionalism still enabled him to get the shot… especially on an unforgettable day in 1951. And in their quiet, reflective moments—on a practice field or in the locker room—Barney was there to record a smile, a laugh, a private reaction.

The Dodgers were legendary for what they did between the lines of a baseball diamond. But before you look at the games, look at the faces.

September 30, 1951: The Dodgers celebrate in the Shibe Park clubhouse following their nerve-racking 9–8, 14-inning victory over the Phillies that forced a season-ending first-place tie with the New York Giants after they had led the race by as many as 13½ games. Clockwise from lower left: Rocky Bridges, winning pitcher Bud Podbielan, Clem Labine, business manager Harold Parrott, Jackie Robinson (who made a game-saving catch in the twelfth inning, then hit a game-winning homer in the fourteenth), sportswriter Joe Trimble, Pee Wee Reese (holding can), Don Newcombe (partially hidden), Roy Campanella, Manager Chuck Dressen, Coach Jake Pitler, Carl Erskine (in jacket), and Erv Palica (upper right corner). In his memoirs, Barney called this fateful afternoon "14 of the most nerve-wracking innings I have ever witnessed, and the best baseball I have ever seen."

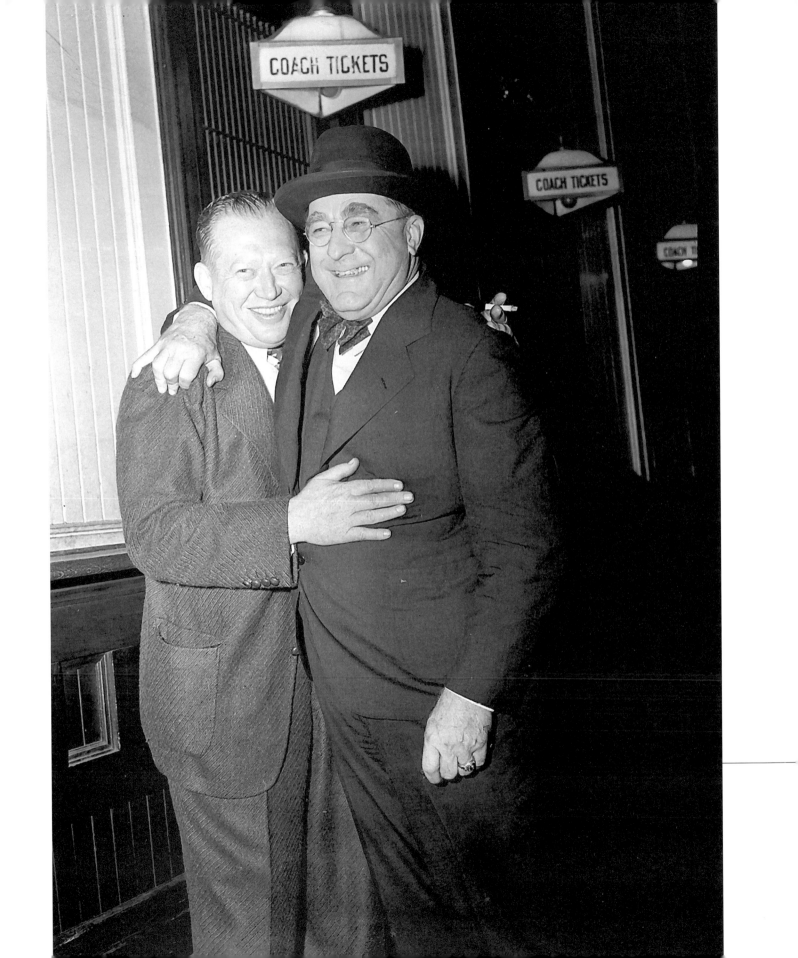

Somewhere in the night, the Dodgers' train is hurtling toward an adoring crowd of 10,000 fans at Grand Central Station, after the team nailed down its first National League pennant since 1920 with a 6–0 win that afternoon—September 25, 1941—in Boston. When the train stops at 125th Street, team president Larry MacPhail will climb aboard to greet his victorious club and share the triumphant ride into Grand Central, accompanied by his friend and mentor, Branch Rickey.

What happened next, well…

BARNEY STEIN: "I was with Larry MacPhail at the 125th Street station of the N.Y. Central waiting for the train to stop there. We were to board the train and proceed with the victorious Dodgers to a huge throng awaiting the team at Grand Central. But somehow the signals were crossed and the train sped right through 125th Street like a flash, and was Mr. MacPhail mad! He called me and his secretary, and we hopped a cab to go to the Hotel New Yorker where the Dodgers were staying, and Mr. MacPhail stormed into the room where [manager Leo] Durocher was and demanded to know why the train didn't stop at the station. And if I remember correctly, Mr. MacPhail fired Durocher on the spot."

Durocher, fearing some of his players would bolt the train at 125th, ordered the conductor to rumble right on through, never guessing that the train would rumble right past his boss. The subsequent firing lasted only a few hours, and Leo was back at the Dodgers helm in time for the World Series against the Yankees.

An interesting note about this photo: although he would play the pivotal (and trailblazing) role in building the postwar Dodgers, Rickey was still more than a year away from joining the team when this shot was taken. In October 1941, he was still general manager of the Cardinals and was in New York on this day to travel upstate to Rochester for the International League playoffs.

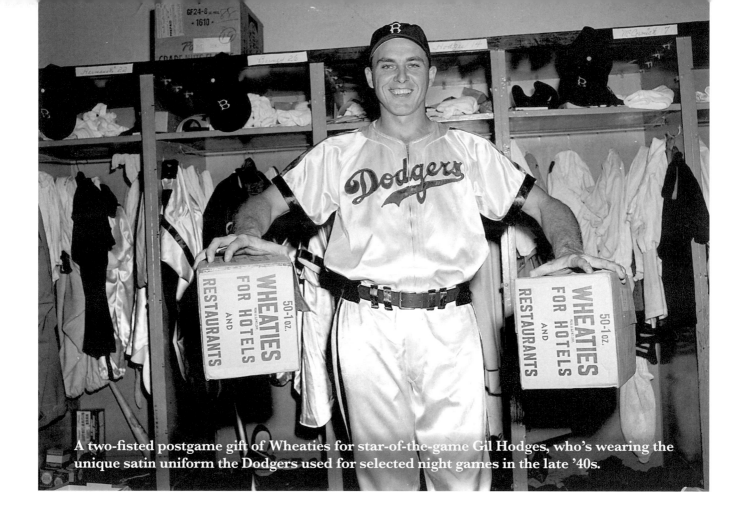

A two-fisted postgame gift of Wheaties for star-of-the-game Gil Hodges, who's wearing the unique satin uniform the Dodgers used for selected night games in the late '40s.

JOAN HODGES: "Wheaties was one of our sponsors at the time. And because of the 11½-inch hand span that Gil had—if you notice the way he's holding the boxes—that's why that picture was taken, to show the extension of his hands."

VIN SCULLY: "I remember seeing them in the Polo Grounds, and they wore the *visiting* satins, which were blue. And when they came out of the clubhouse in the old Polo Grounds, under the lights, on the green grass, with those uniforms shimmering, I mean it was show business of all time! Eventually, those uniforms wound up in Vero Beach, and every coach and minor league manager and instructor wore the satins. So that as soon as you saw a satin uniform, you knew that man was in administration."

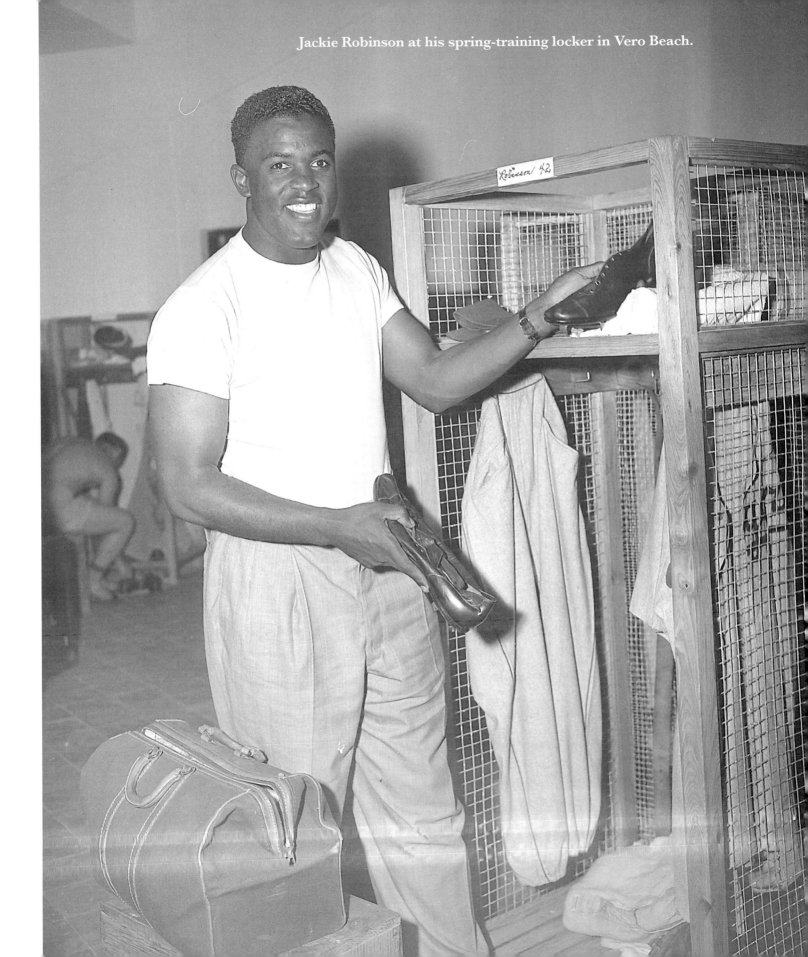
Jackie Robinson at his spring-training locker in Vero Beach.

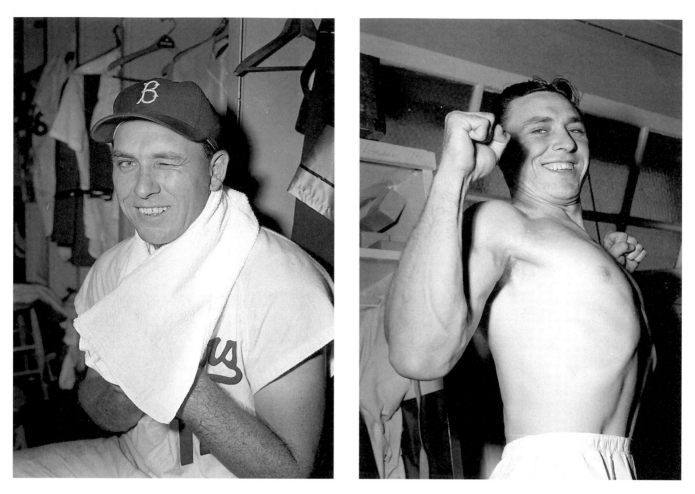

Gil Hodges winking, Gil Hodges flexing.

JOAN HODGES: "Now, would you believe I've never seen those ones you have of Gil in the locker room sitting there? My goodness, I can't believe it. Never saw them."

VIN SCULLY: "And of course, Hodges—and I've said it on the air—was probably the great, great hero in the sense that he was straight-arrow. Every player absolutely respected him. Reese, of course, was the captain, but I think even Pee Wee had that extra feeling about Gil. There was something very special about him. Former Marine, stories which he never mentioned where, they said, [he was] in hand-to-hand combat and all that stuff. But he was quiet, gentle, and just an incredible man, and one of my all-time favorite human beings, in baseball or otherwise. I still will go to my grave regretting that he [hasn't] gotten into the Hall of Fame."

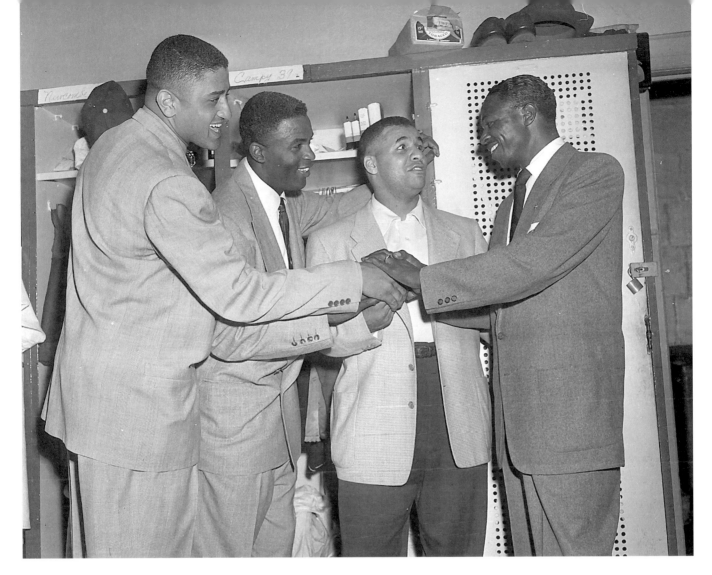

Don Newcombe, Jackie Robinson, and Roy Campanella greet a gentleman who had been listed as "unidentified," until…

DON NEWCOMBE: "That's Billy Rowe. Billy Rowe was a former police commissioner in the city of New York and one of the instigators and forerunners of making it possible for *this* man, Jackie Robinson, to be signed to a contract by what he would say and write in the papers. And we always appreciated this man. He was a great man in helping [pioneer African American writers] Wendell Smith and Sam Lacy, and Billy was a writer of sorts himself for a paper even though he was a police commissioner, he was also a media man in New York with the *Amsterdam News*. He was very instrumental in helping to open doors and the minds of people like Branch Rickey to make it happen, that they should have black players in the major leagues. He was a fine man."

Barney Stein took the most famous and dramatic photo of his career in the late afternoon of Wednesday, October 3, 1951: the unforgettable shot of Ralph Branca slumped over in a silent Dodgers clubhouse after allowing Bobby Thomson's three-run, game-winning homer in the third and deciding National League playoff game against the Giants at the Polo Grounds. One of the most enduring photographic images in American sport, it is accompanied by another shot of Branca—now having shorn his No. 13 jersey—face down on the clubhouse steps next to Coach Cookie Lavagetto.

BARNEY STEIN: "Let me relate my story of that day. I had made pregame photos, features of celebrities, then action during the game. I proceeded to the photographer's cage overhanging from between third and home—the best seat in the park!—and when we were ahead in the eighth inning, I was sure we were going to win the pennant. I left my perch to battle the crowd to go to the Dodgers clubhouse [in center field], where I saw the rest of the game in the bleachers.

"Came the ninth inning, everyone in the ballpark was tense when Don Newcombe was sent to the showers and Ralph Branca was sent to relieve him by manager Chuck Dressen. We were still ahead 4–2, and the next batter could be a hero if he got any kind of a hit, or he could be the fall guy.

"I was behind the wire screen in center field craning to see the finish of the game. When I heard the crack of Thomson's bat, I groaned, 'No, no, it can't be!' But it was, and pandemonium broke out when the whole Giants team surrounded home plate to welcome Thomson. I'll never forget a sad Ralph Branca striding from the pitcher's mound to the Dodgers clubhouse at the Polo Grounds.

"The visiting team's clubhouse adjoins the Giants'. No photographer or sportswriter was allowed into the Dodgers clubhouse. The Giants' victory was being celebrated, and the photographers and writers went there. I stayed with the other photogs at the bottom of the Dodgers clubhouse until they went over to the celebration party. I stayed alone until I was finally admitted by Manager Dressen, and the first one I saw was a dejected Ralph Branca sobbing bitterly on the stairs inside the clubhouse. I saw a history-making picture before me. I just had to 'shoot away,' and I still remember a *Daily Mirror* sportswriter whispering into my ear, 'Barney, that's sure a prize winner!' I hated to take

the picture, but I realized it was the best sports story of all time and this was the picture to describe it. Later on Ralph didn't reproach me, for he knew it was my job."

RALPH BRANCA: "I remember him taking the picture, but at that point in time I really didn't give a good crap, you know? (Laughs) I just remember when he was taking it, at that point I said, 'I don't really give a good crap.' He was just doing his job.

"They gave me the photo of me sitting on the steps. Barney and I were close friends—he took our wedding pictures—and he gave me a print and the negative. I [still] have the negative. I have a bunch of pictures Barney gave me which I've never done anything with, that are sitting in a drawer somewhere. They gave me that because they thought I should have it.

"The picture never bothered me. Barney was doing his job. I understood that, and I knew he was taking it. I didn't give a damn at that point, you know? But Barney was a friend, and 17 days later, he took our wedding pictures, and they were great. Like I said, with Barney you're working with a professional."

The classic Branca photo found a new audience in 1980, when the New York Mets used a full-page version of the shot to anchor their print advertising campaign...without consulting the photographer or his subject.

RALPH BRANCA: "I called the Mets up and I was really pissed. To be blunt, I wanted to sue them because there's a law and I don't know what it's called, but it was an invasion of my privacy to use that in an advertisement without my consent. It was against the law, the civil rights law, whatever the hell it was. So what can I tell you.'"

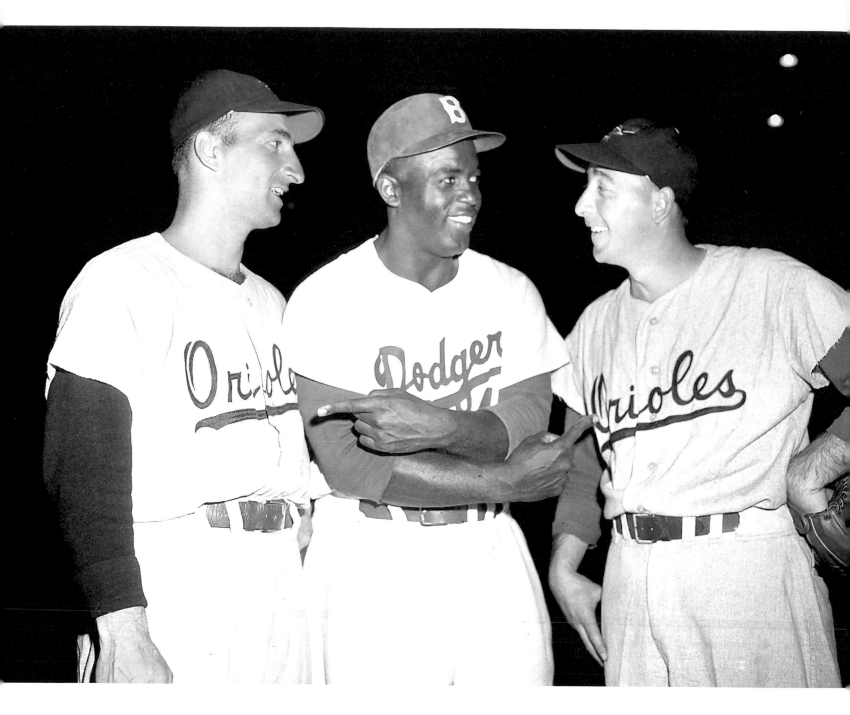

Jackie with old teammates Cal Abrams (left) and Billy Cox, newly hatched in '55 as Baltimore Orioles.

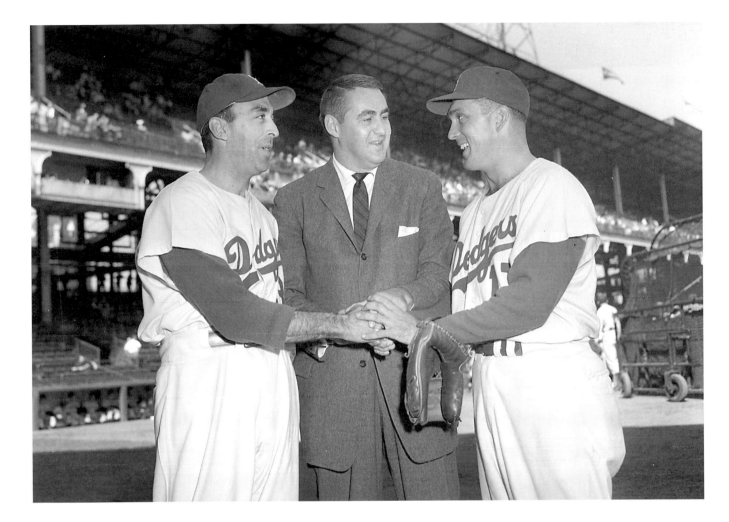

The last three men to pitch a no-hitter for the Brooklyn Dodgers: Sal Maglie (September 25, 1956) and Carl Erskine (June 19, 1952; May 12, 1956) flank pitcher-turned-announcer Rex Barney (September 9, 1948).

CARL ERSKINE: "The three no-hit pitchers? Then it had to be in '56. Maglie and I both pitched no-hitters in '56. I pitched mine in May, and Maglie's was later in the season. Rex's was in '48 in the Polo Grounds, in the rain. I saw that one, it was a night game. The last out, the rain was coming down and Bruce Edwards was catching. I don't remember who the hitter was [Whitey Lockman], but there was a high pop foul that came over toward our dugout and Bruce Edwards ran it down and caught it looking straight up into those lights and into the rain. It was amazing.

"The last three guys to pitch a no-hitter for the Brooklyn Dodgers? Well, this is trivia and I didn't know it. Fans tell me things about my career that I never knew."

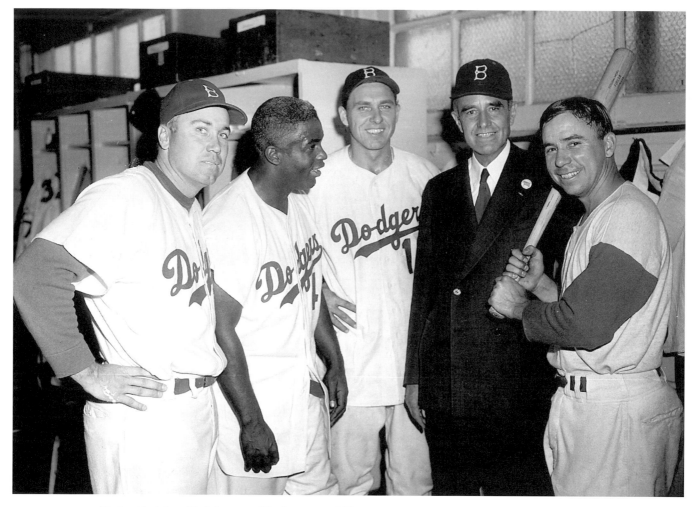

Duke Snider, Robinson, Hodges, and Reese greet a distinguished guest: New York State governor Averell Harriman.

DUKE SNIDER: "He used to come into the clubhouse quite often. I can't understand why Pee Wee's got a bat in his hand…it might be why we were laughing a little bit. I would tell Pee Wee, 'You should always have a *glove* on your hand!' But we're all smiling and over by Pee Wee's locker in the Captain's Corner."

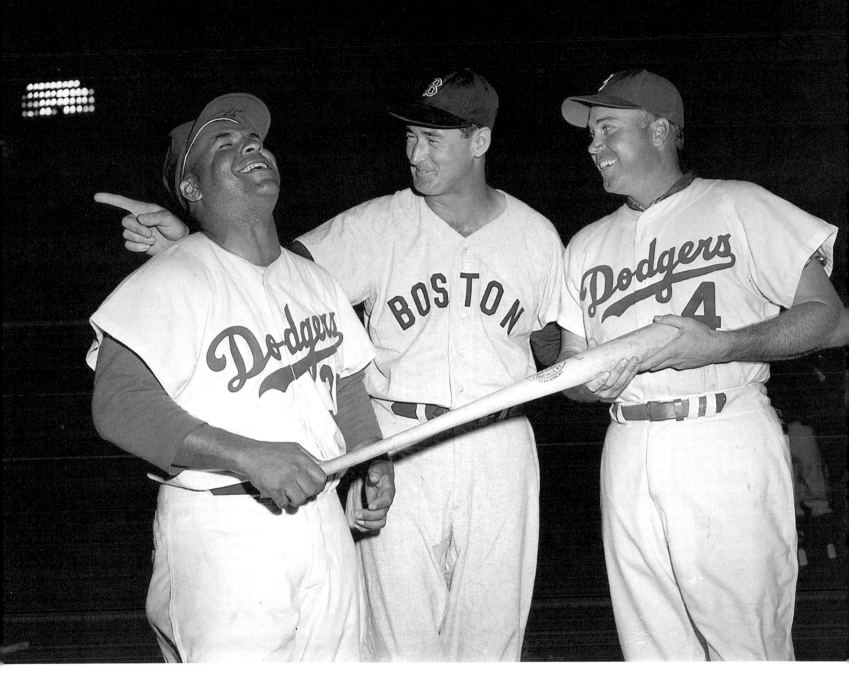

**You just *know* they're talking about hitting: Campy and Duke with
Ted Williams before a spring training game in Miami.**

DUKE SNIDER: "Campy's laughing pretty heavy there, so I guess Ted
must have said something rather amusing. That's the only time we ever saw
Ted Williams, because we didn't play them, of course, during the season. We
always looked forward to getting together and playing the Red Sox in spring
training because he was such a neat guy to be around. That's a unique photo-
graph, I don't think I've ever seen it before."

Who won? Who lost? Robinson and Yankees manager Casey Stengel en route to their respective locker rooms following a World Series game.

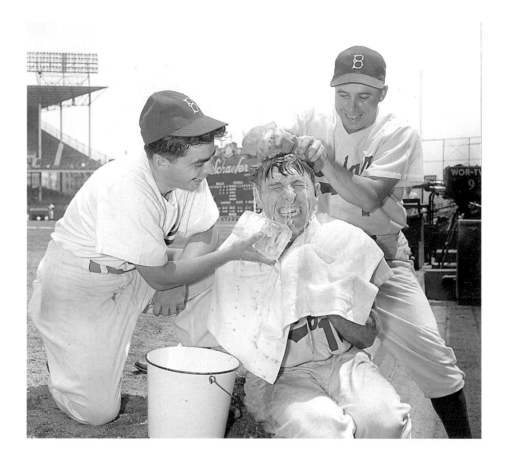

On a steaming-hot day in Flatbush, Hodges is cooled off by Reese (right) and legendary batboy Charlie DiGiovanna. "Charlie the Brow" tended to the team for most of the 1950s until his heart, weakened by a childhood illness, gave out in December 1958. He was 28 and left behind a wife and three children.

JOAN HODGES: "[Charlie] *was*, in every sense of the word… He died a young boy, but he was really 105 when he died. Charlie and Shirley DiGiovanna were two very, very special people, they really were. He was such a hard worker and he lived, absolutely lived, for [the Dodgers]. And they loved him so. I remember the day he died, Eddie Roebuck called and told us, and they immediately got together to do something as a team. He was very, very special to us."

CARL ERSKINE: "He was a street kid in Brooklyn and he was a little roughneck. Kind of crude in his behavior and his language, but you know what? He was the most loyal to that team. And the thing I admired about Charlie [was that] we had some superstars on that team. And some guys were good tippers and some guys were not. Some guys really ducked and tried to worm out. But Charlie, to his credit, treated everybody the same. He did not hold a grudge against a guy that cheated him out of a tip or roughed him in some way. He still got his uniform hung up right, his stuff dried properly, his shoes cleaned. And I always admired Charlie for that because I knew some guys didn't treat him very well. But he was so loyal to that ballclub. He was a smart street kid, and typical Brooklyn, with a heavy accent. We all admired Charlie because he was such a dedicated person. He didn't care what he made because he just wanted to be where he was."

It's April 21, 1955, and what the Bums have "dood" is win their 10th straight game at the start of the season, becoming the first major league team to get off to a 10–0 start. Manager Alston breaks the symbolic record over the head of Don Zimmer, who had four hits in the 14–4 win over Philadelphia. Looking on are Robinson, winning pitcher Joe Black, Snider, and Hodges.

DUKE SNIDER: "Probably the only picture you'd ever see after seeing Zimmer get four hits! I can see Zimmer's quaint little smile right there, before he put all that weight on. But he was, and still is, a special friend of mine. I don't remember him getting four hits, but I'm sure that he does!"

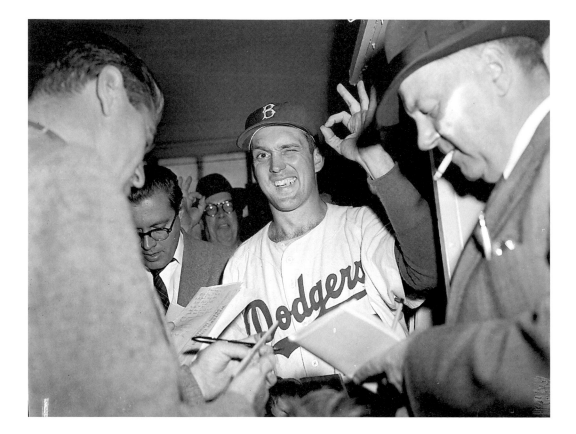

Carl Erskine beams after blanking the Giants, 3–0, on May 12, 1956, for his second career no-hitter and the first of two Dodgers no-hitters that season.

CARL ERSKINE: "That's Red Patterson with the cigarette, and Happy Felton in the background. You know, I remember this picture. They originally cropped the picture and just used me in it, and it was in either *Newsweek* or *Time*, because I had had a lot of arm trouble and the article was about mind over matter and having a positive outlook, something like that. I don't recognize the other two. The guy writing, is that Dick Young? Was Young left-handed? [He was.] I don't know who the guy with the glasses is. It just doesn't hit me who that could be."

Four months after Erskine's gem and in the last days of a heated pennant race, former Dodgers nemesis Sal Maglie shut down Philadelphia, 5–0, on September 25, 1956. Sal got a police escort off the field, amid a handshake from Dale Mitchell (in jacket).

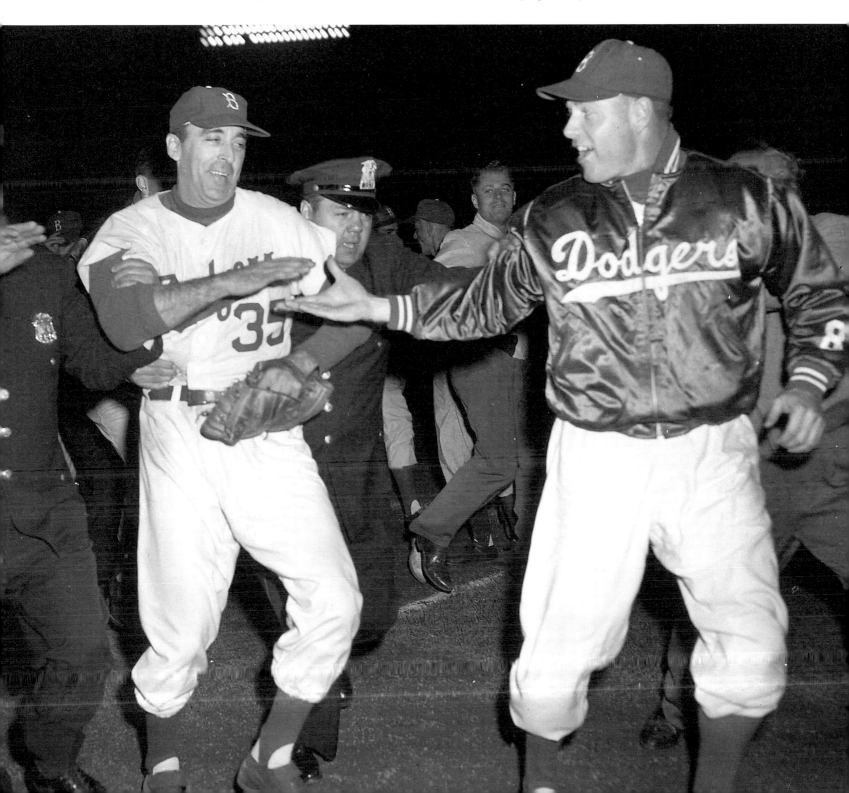

CARL ERSKINE: "Here's a shot of the 1956 pennant clincher. We're pouring beer, it looks like, on Pee Wee. The man in the hat is Red Patterson. That's Newcombe, pouring with his left hand, Don Bessent in the middle, and I've got both hands on top of Pee Wee's head. That went to the final day."

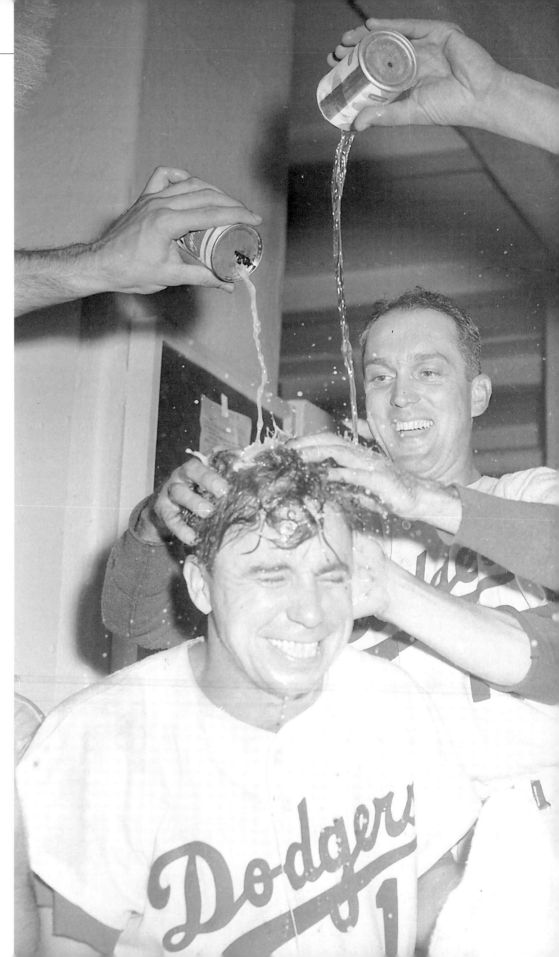

The last golden moment for the Dodgers in Brooklyn came on the final day of the 1956 season, when they defeated Pittsburgh 8–6 at Ebbets Field on September 30 to clinch their last NL pennant before heading west.

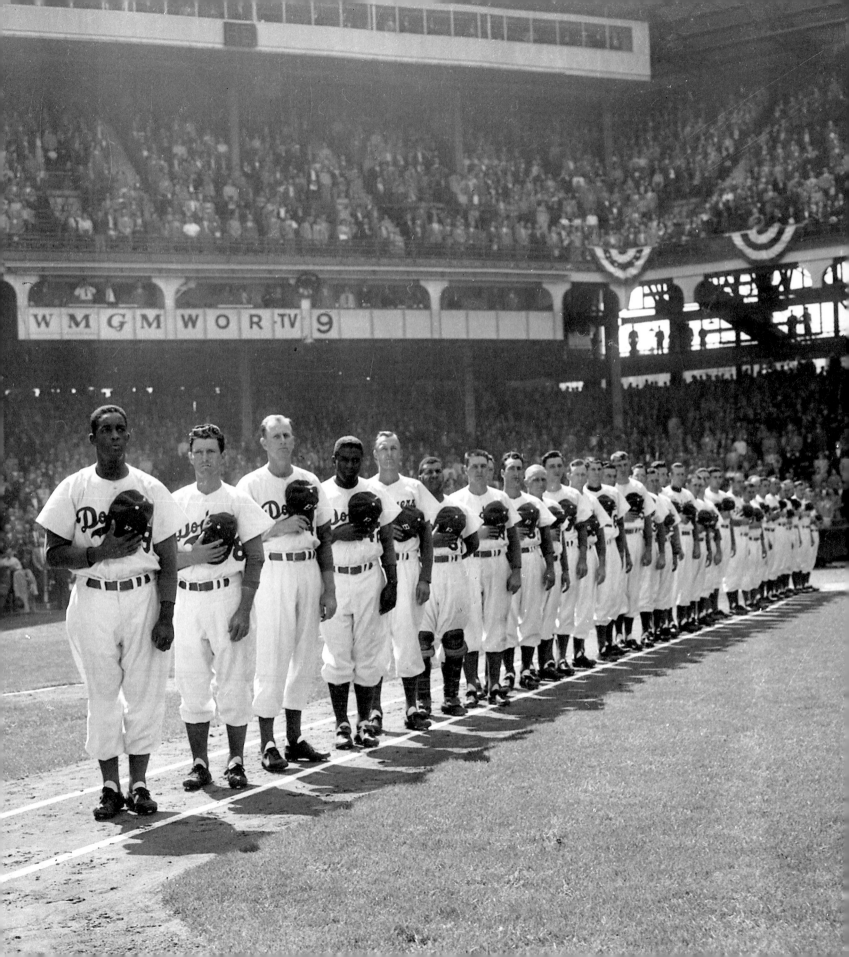

On the Field

When Barney started shooting the Dodgers, press photographers were allowed to position themselves on the field (in foul territory, of course) during the game, so most of his early action shots were taken just a few feet away from the action itself.

Allowing photographers to work on the field was a baseball tradition that, in most major league parks, stretched into the 1950s. In Cleveland's old Municipal Stadium, photographers were permitted on the field as late as the 1970s.

But in Brooklyn, it was a custom that ended much earlier, in the early '40s. All it took was one mishap and a predictable explosion from Larry MacPhail, as Barney explained in his memoirs.

"In the old days, we were allowed to shoot pictures from the field, and it was a little tough running from one base to the other to get our action shots," he wrote. "Until one night game an incident occurred in a close play of a ball thrown from the outfield to third base. We photogs were waiting for some action at third when the opposing batter hit a ball to left field—the runner on second streaked toward third, and the left fielder threw to third

The Dodgers line up for their 1952 home opener—April 18, 1952, against the rival Giants. The first seven in line are Joe Black (who would win NL Rookie of the Year honors), Andy Pafko, Ben Wade, Jackie Robinson, Johnny Rutherford, Roy Campanella, and Dick Williams. Six months removed from the Bobby Thomson nightmare, they would beat the Giants 7–6 in 12 innings, en route to the first of four pennants in the next five years. This day also marked a unique first, as the Dodgers became the first team in major league history to wear uniform numbers on the *front* of their jerseys, as well as on the back (inspired, no doubt, by the team's extensive home TV schedule).

base; but, alas, the ball hit one of the photogs, and the player scooted on home to score.

"Larry MacPhail, then president of the Dodgers, saw the whole incident and was furious at us, and he ordered us off the field and to take our pictures hereafter from the photographer's cages overhanging the field. These cages are best for photogs with 'Big Bertha' lenses, and it's very easy to cover a game from up there. All you had to do was to make markings on your camera for home plate, first, second, third, and outfield shots no more running around the field to cover the bases. That third-base incident was our good fortune, I think. Nowadays we have chairs in our photographer's box, and we even get refreshments from the management!"

After that, Barney took the majority of his action shots from up above (at Ebbets Field, there were two overhanging photo boxes, one above first base and the other above third). His images of the Dodgers on the field of play were no less dramatic, no less compelling, than those taken when he was ducking errant throws from left field.

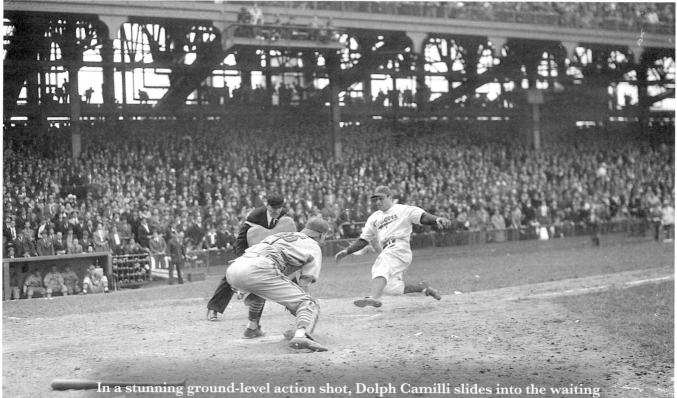

In a stunning ground-level action shot, Dolph Camilli slides into the waiting tag of the Cardinals' Walker Cooper in late 1941. The umpire is Lou Jorda.

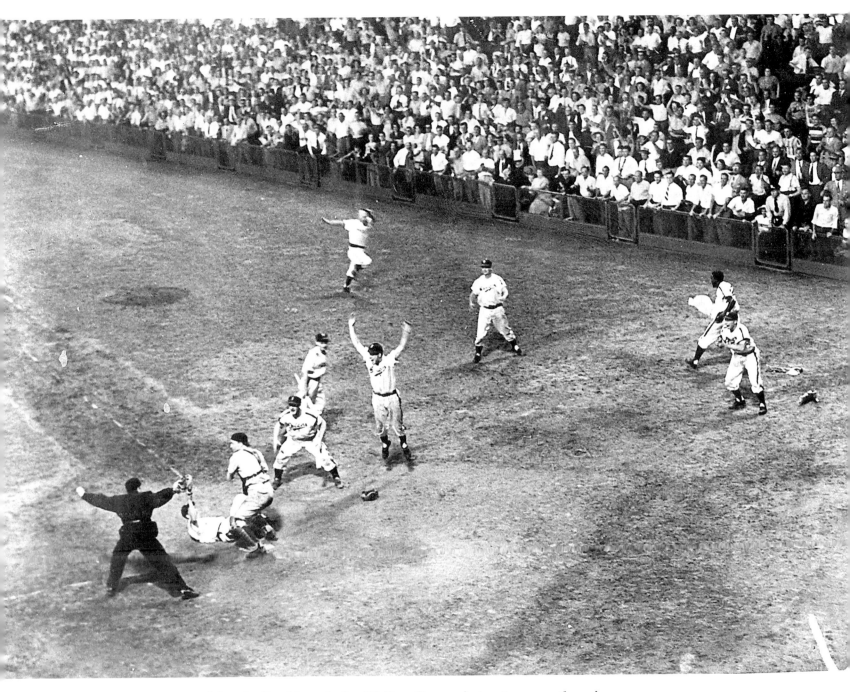

Marvin Rackley eludes Walker Cooper's tag to score the winning run on Billy Cox's double in a 6–5, 10-inning victory over Cincinnati, July 14, 1949, to the delight of a celebrating Duke Snider (arms up); Bruce Edwards; Gene Hermanski; Jackie Robinson; and Coach Jake Pitler.

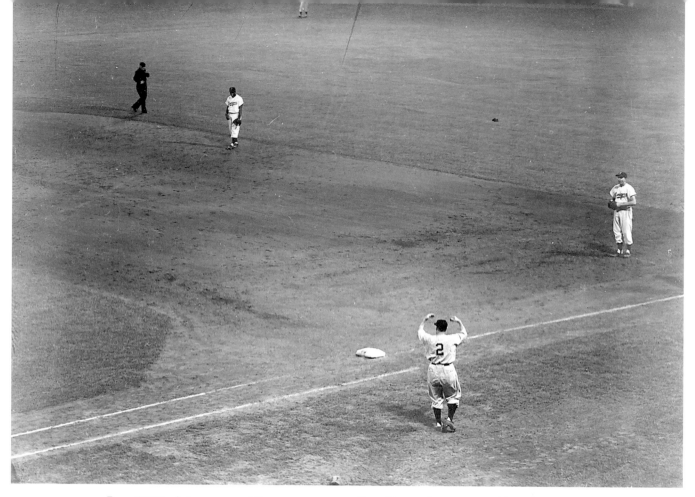

In a 1950 night game, Giants manager Leo Durocher—coaching at first base—gestures toward the field, as Hodges (1B) and Robinson (2B) man their positions. The source of Leo's gesture remains a mystery.

DON NEWCOMBE: "We always had our run-ins with Leo. Jackie and Cookie Lavagetto used to needle me to get into Leo about wearing Laraine Day's perfume and stealing Babe Ruth's watch when he was a player and stuff like that. At Ebbets Field, there was a little storeroom between the two clubhouses with doors, and Ralph Branca and I used to get into that storeroom and yell through the door to Leo, 'Eat your heart out!'

"Whether Leo's [getting] on Jackie [in this picture], I don't know, because he's coaching first base. I think the way the umpire is running out, that Leo's cheering wherever that ball was hit, instead of yelling at Jackie. Jackie and Gil are just standing there. I don't think he's taunting Jackie. I think he's cheering what happened, or where that ball went, instead of riding Jackie. Of course, Jackie was pretty good at riding, too."

April 25, 1953, and just another day in the life of the Giants and Dodgers. After ducking a Sal Maglie brushback pitch, Carl Furillo sent his bat sailing in Maglie's direction on the next delivery. Hodges (No. 14) and Reese (No. 1) try to intercept Furillo before he can reach Maglie (second from right), with Robinson (No. 42), Campanella (No. 39), and George Shuba (No. 8) in pursuit. Later that season, on September 6 at the Polo Grounds, Furillo and Durocher duked it out, and Furillo came out of the mêlée with a broken hand that sidelined the NL batting champion (.344) until the World Series.

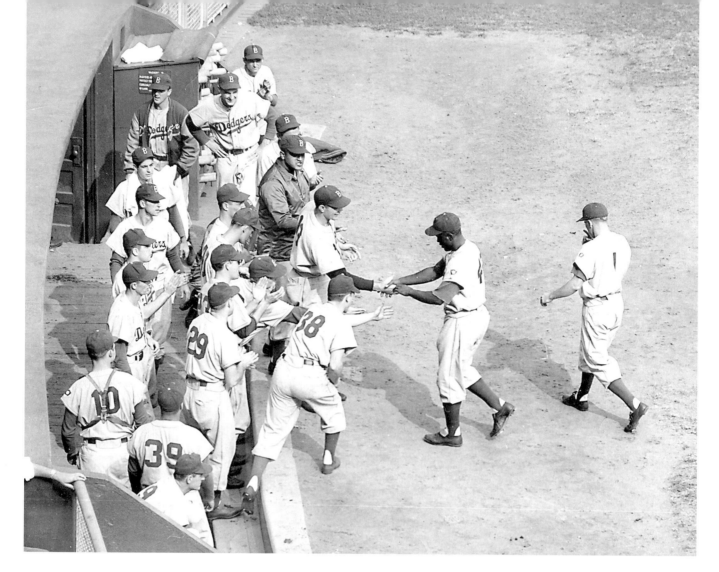

Robinson hits the dugout at the Polo Grounds following his home run in Game 2 of the 1951 NL playoff against the Giants. Among the welcoming committee are Reese (No. 1), Dick Williams (No. 38), Don Thompson (No. 29), Rube Walker (No. 10), Campanella (No. 39), and Newcombe (in windbreaker). Rookie Clem Labine shut out the Giants on six hits as the Dodgers won, 10–0.

CLEM LABINE: "I think I certainly put myself in position to pitch, and being someone you could depend on one way or the other. I didn't scare that easily. They brought me up in June or July from St. Paul, and I met them on crutches. Can you imagine? They brought me up to help with their pitching staff, and here I am on crutches. I hurt myself the same day they brought me up, hitting a catcher at home plate trying to score. Barney didn't get that picture, though. That was in Kansas!"

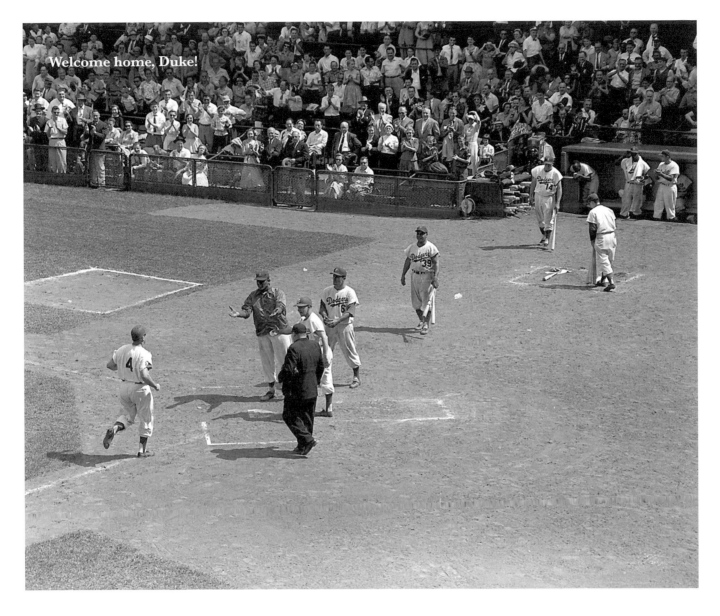

Welcome home, Duke!

DUKE SNIDER: "That's Campy third one back, I think. Pee Wee is standing by the umpire, and he must have been on base. Newk with the jacket. Campy was the next hitter. It could have been a game-ending thing. Newcombe could have been on base, too, or otherwise he wouldn't have been out there."

All eyes in Yankee Stadium
are on Andy Pafko as he scales
the low right-field wall to rob
Gene Woodling of a home run
in Game 5 of the 1952 World
Series. Later in the game,
Carl Furillo would deny Johnny
Mize's home-run bid at almost
the same spot, preserving
Carl Erskine's heroic 6–5,
five-hit, 11-inning win that gave
the Dodgers a 3–2 Series lead.
(continued on pg. 32)

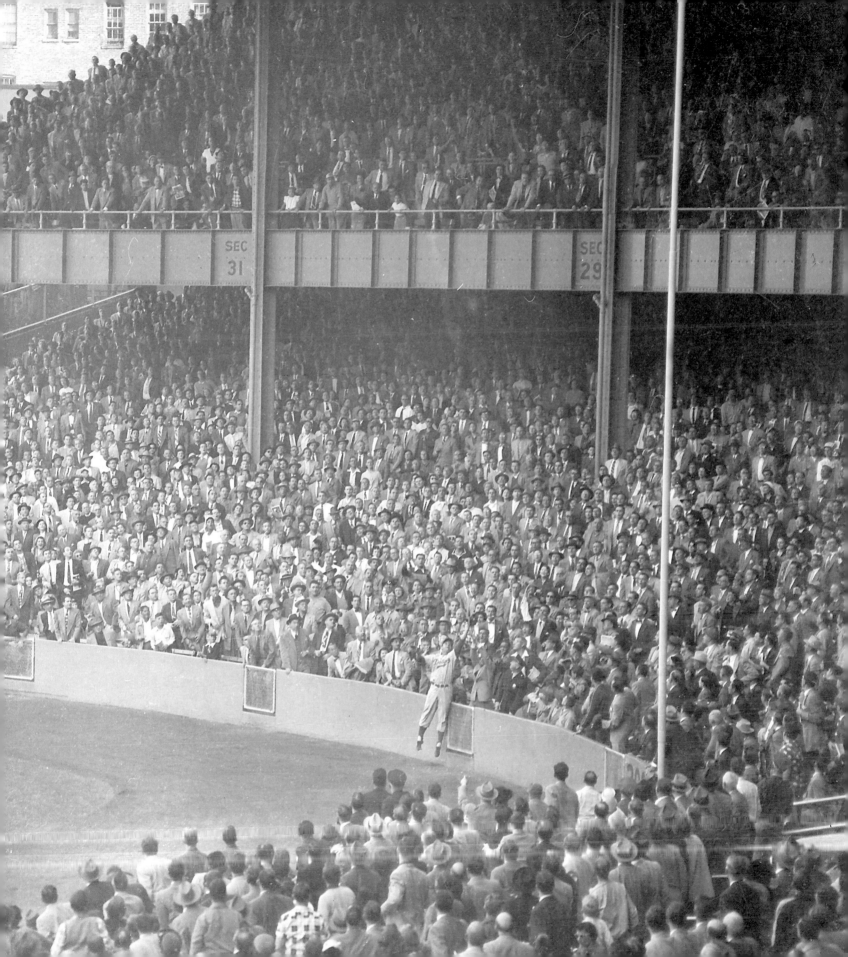

(continued from pg. 30)

CARL ERSKINE: "Fastball inside. Woodling was one of the pure hitters. He had power, but he didn't hit a lot of home runs. But that short porch in the stadium, with a low line drive like that, that's only about 300 feet. That's Pafko, and later, Furillo robbed Mize, that's right.

"Mize was a really tough out, he's really the one that cost me the extra innings because I threw him a terrible pitch in the fifth, and he hit a three-run homer. That capped a five-run fifth inning. We'd started the inning up 4–0, and I gave up five runs in the fifth inning, the big blow was Mize's home run. Then Dressen, I can't figure out how he left me in the game, but he did. I thought he was going to pinch-hit for me, but he said, 'No, you're my hitter, get up there.' And then the game went 11 innings and we finally won it. And from the time Mize hit the home run until I struck [Yogi] Berra out to end the game, I got 19 consecutive outs.

"That's the game with all the fives. Vin Scully relates this story, because not only was it the fifth game, the fifth of October, my fifth wedding anniversary, and the Yankees scored five runs off me in the fifth inning. Now, before the game I got a telegram that a guy in Texas had sent me saying, 'Good luck on this fifth game of the World Series, on the fifth day of October, on your fifth wedding anniversary.' I got that in the clubhouse, and Red Barber came by and I showed it to him and he said, 'Can I take it up to the booth with me? That's kind of interesting.' So they had this five thing going, and when they got five runs in the fifth off me, Scully said, 'Man, now I'm watching for *anything*, any other fives.' Then he said, 'You know what? When you struck Berra out to end the game, I just happened to glance at the clock in the Stadium. It was five minutes past five!' That's a true story, but it's kind of weird."

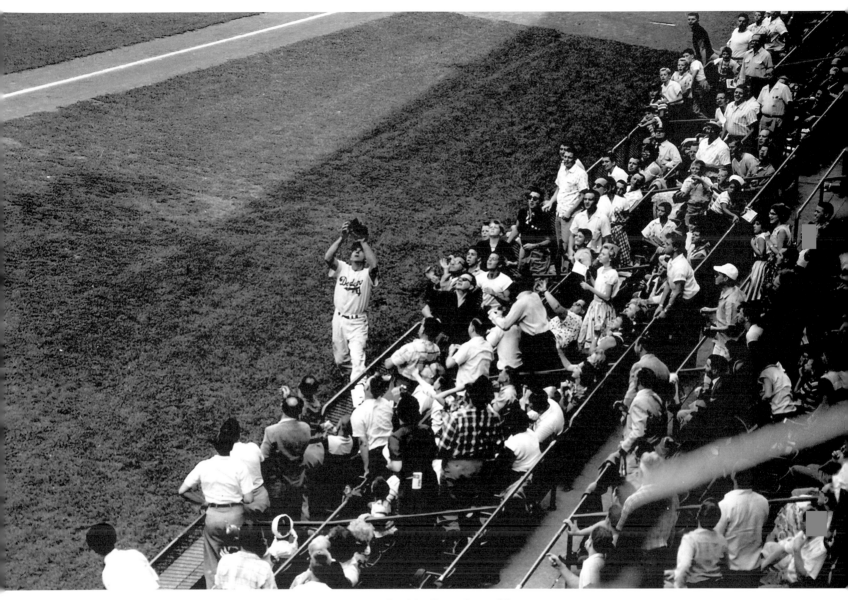

Hodges gracefully snares a foul ball at the railing.

VIN SCULLY: *"Life* magazine did a pictorial with Gil playing first base and, I don't think it was [Vaslav] Nijinsky, but it was some ballet artist. And they would show you a ballet move and then there was a picture of Gil stretching, and you matched them up. And when you saw the size of the man and those hands, you were amazed that he could be so agile and graceful in the minimum amount of effort. It was amazing. And because of those hands, a lot of the pitchers, when they got a ball, they would give it to Gil…not so much to rub it up, but he could actually squeeze it and raise the seams a little bit."

And sometimes—too often, actually —it went the other way. It is October 10, 1956, and somewhere in that pile near home plate is a 23-year-old named Johnny Kucks, who has just pitched a three-hit shutout to give the Yankees a 9–0 win in the deciding seventh game of the World Series. No one could know it at the time, but Ebbets Field would never see another postseason game.

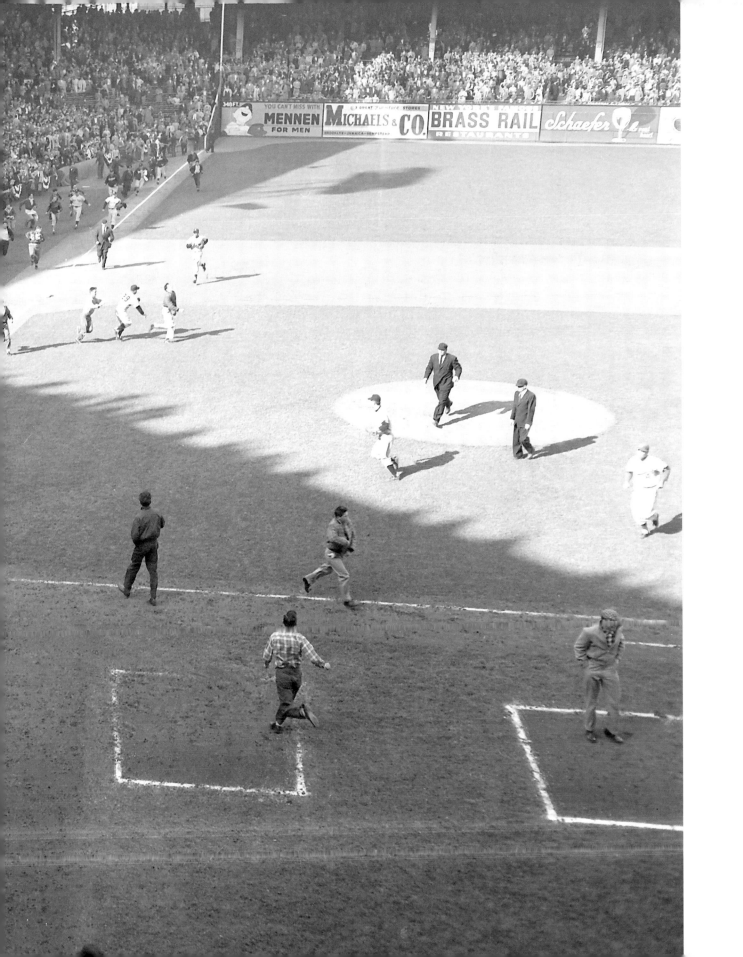

THREE

The Supporting Cast

Away from the field—in the front office and the executive box—was another Dodgers team. And this one was just as vital and important to the team's story, and just as intriguing a photo subject for Barney Stein, as the men in uniform.

It began with the Roaring Redhead. There was the Bambino, for a little while anyway. And the Mahatma. There was the Big O. And Buzzie and Fresco.

And—wouldn't you know?—even a red-haired announcer who, more than half a century later, was still part of the scene.

Barney—for once without his camera—in a TV interview with a youthful Vin Scully.

VIN SCULLY: "This was probably during the intermission of a doubleheader, [with Barney] as a guest. We would interview people. Now, I don't see where we were showing Barney Stein's pictures. In those days, we didn't do very much studio work—we didn't do a pregame show or a postgame show—so I would have to guess this would be the intermission. This [studio] was in the basement of Ebbets Field."

Larry MacPhail was dubbed the Roaring Redhead with good reason. During a frantic five-year tenure as Dodgers president, he renovated Ebbets Field, brought night baseball to Brooklyn, put the Dodgers on radio and television, battled with the press, fired Leo Durocher countless times…and built the 1941 National League championship team that ushered in the modern age of Dodgers dominance. Barney's shot of a rumpled, grinning MacPhail in the Ebbets Field press box was characterized by Red Barber as the one "most typical" of this unpredictable innovator.

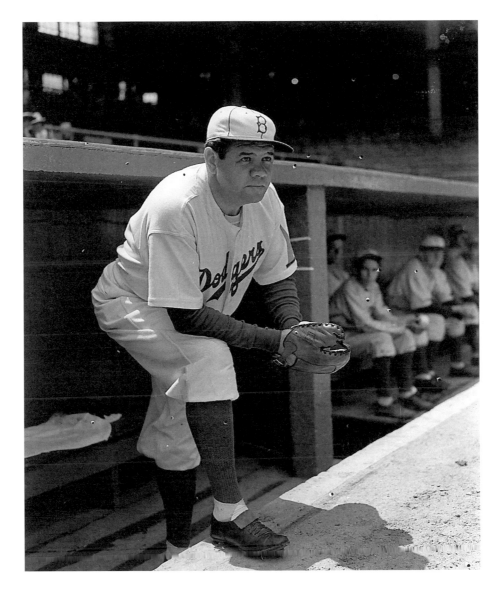

MacPhail brought in the Bambino himself—Babe Ruth—as a first-base coach/drawing card in 1938, a stint that lasted just one season. It would be the last time the Babe would be affiliated with a major league team in an official capacity (1938 also marked the first year the unmistakable "Dodgers" script—virtually unchanged for nearly 70 years—appeared on the team's home jerseys).

BARNEY STEIN: "I was a bit shy in those years, and I was in awe as I approached the greatest player in baseball and asked him to pose for me. The Babe looked at me and said, 'go ahead, kid!' I then loosened my tongue and told the Babe that I was at Yankee Stadium one day when he socked a home run into right field . . . I cut school that day from Stuyvesant High School."

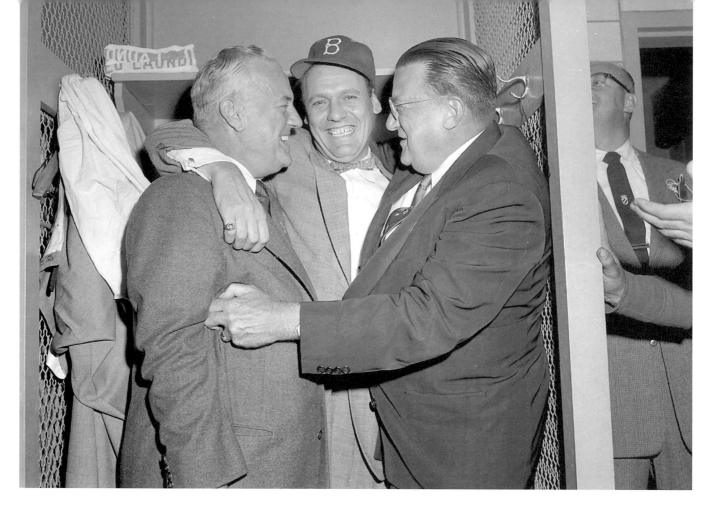

The Big Three of the Dodgers front office celebrates after Game 7 of the '55 World Series: president Walter O'Malley (right) with vice presidents Buzzie Bavasi (center) and Fresco Thompson. While O'Malley and Bavasi would gain more fame and notoriety during their careers, the efforts of Thompson over a half-century as player, scout, executive, and raconteur were equally important to the Dodgers' success during the Brooklyn days.

BUZZIE BAVASI: "Great, great sense of humor, absolutely. And a great judge of talent. Not too many people know this, but he took over for me at the Dodgers when I came down here [to San Diego], but he only lasted a short time because he passed away. Great, great man. Everybody liked him, and I never heard anyone say a bad word about Fresco."

JOHNNY PODRES: "Fresco was the best one-liner guy I ever knew. I'll tell you a story. Al Ferrara had a good year in the minor leagues, and Fresco was the minor league guy. And Ferrara says, 'I need a raise, my wife just had a baby.' Well, Fresco said, 'I'm not paying for your pleasures.'"

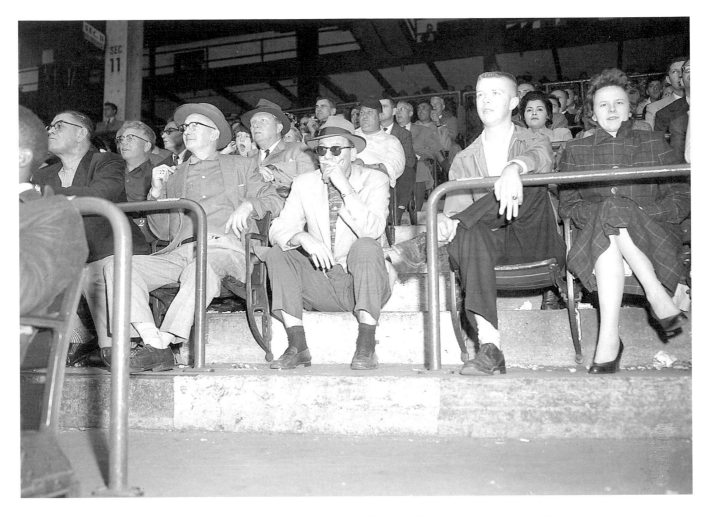

The man behind the sunglasses is Buzzie Bavasi, working undercover in the Ebbets Field stands.

BUZZIE BAVASI: "When I was in Montreal, it was a big Pepsi-Cola town, and a friend of mine gave me the idea. I'd go around the stands, particularly the bleachers. Pepsis were 10¢, and I'd buy the fans a Pepsi, become their buddy, and study them during the game. And they all became fans, for 10¢ they became a fan. So when I went to Brooklyn, I said 'I'm going to do the same thing.' I'd go around the stands, sit in the different sections, and buy the fans a Coke and sit down with them. And that way, I got myself a fan. Usually, I did it on the weekends, when the real fans were there. It was fun, and of course there was nothing like a Dodger fan. I'd say about twice a week, I didn't realize Barney took this picture, to be honest with you."

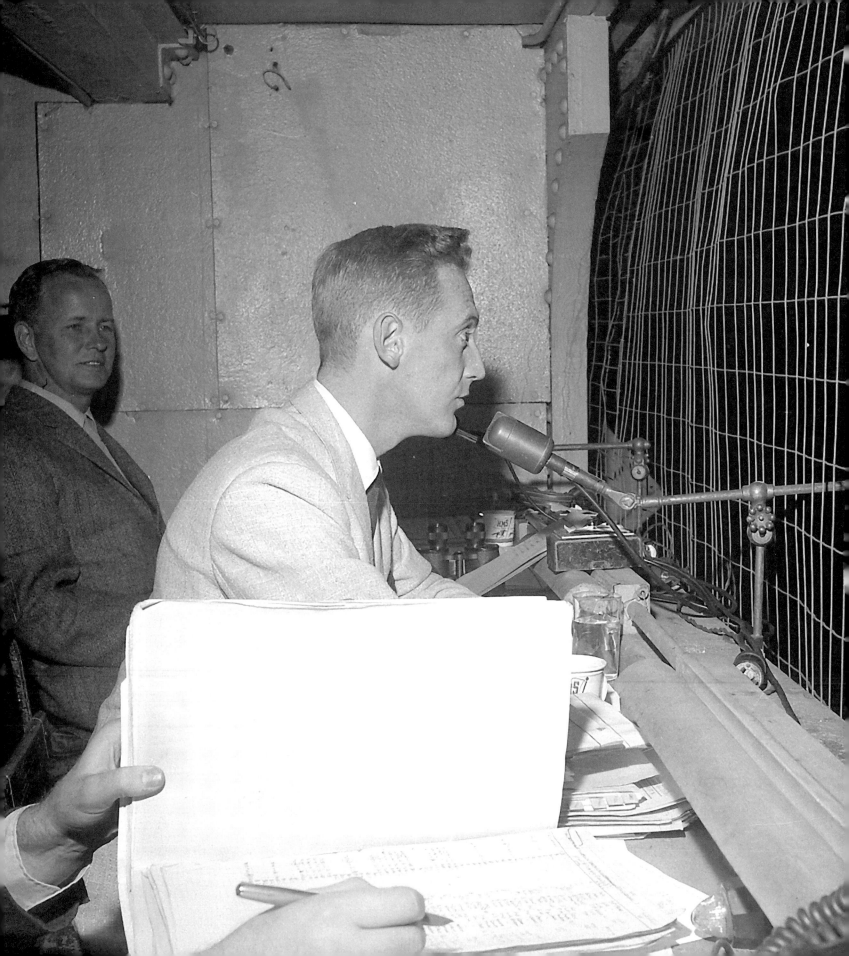

Scully in the radio booth in 1957. Sidekick Jerry Doggett—in the first full season of a 32-year career with the Dodgers, is at far left. The hands in the foreground—working on a chart, not a scorecard—belong to pioneer statistician Allan Roth.

VIN SCULLY, JUNE 4, 1957: "Oh-and-one the count to Zimmer. Last of the second inning, 3–nothing Brooklyn. Dick Drott looks in to get a sign. Zimmer bends at the knees a little bit more now. And the strike-one pitch, fastball cut on. There's a high foul to the right of the plate, [Cal] Neeman coming back right to the lip of the Dodger dugout and can't make it, the ball lands on the roof. And somebody makes a great catch by the name of Barney Stein! Barney, who takes great sports photos for the *New York Post*, he's also the Brooklyn Dodgers official photographer. And that thing kangarooed from the dugout roof right up into the camera booth, and there was Barney to grab it. He dropped a $9,000 camera in the process…naw, not really."

VIN SCULLY: "There's Jerry [Doggett], God bless him. Another thing is the wire [in front of the booth]. When I first came there, there was no wire. The only thing that approximated it was in old Tiger Stadium in Detroit. Balls would come right back, like they were shot out of a bazooka. I think in my very first year, Red was doing the game and wrote something in his book, and the next pitch was fouled and as he looked up, here comes that foul ball. And he threw his wrist up and it hit him on the wrist. And the next day, there was wire there.

"As far as Allan [Roth] was concerned, Allan had a briefcase which equated with Mary Poppins's bag. You'd turn and say something like, 'How many double plays have they turned?' or whatever, and he'd reach in and pull out something and come up with the answer. We were not as statistically minded as we are today. And of course, Allan was a hockey statistician who sold his ideas to Branch Rickey, who then hired him in Brooklyn.

"No headphones, strictly that little old microphone. We really started to get into headphones out here [in Los Angeles], and only after a couple of years [with] the sound in Coliseum and the feedback from the transistor radios, and we eventually went to the headsets."

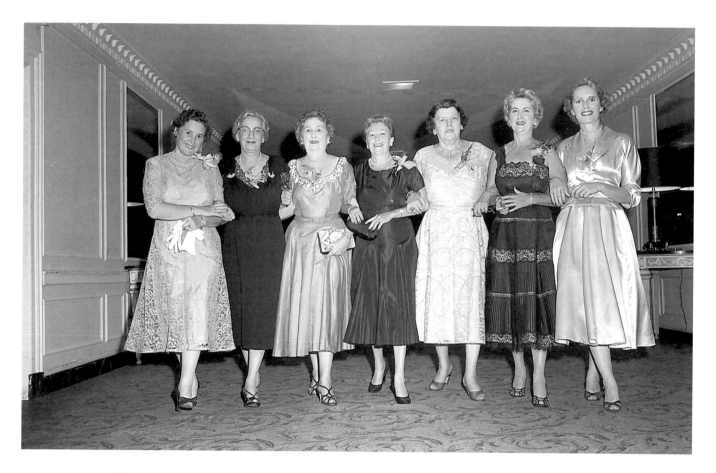

The women behind the men: the Dodgers executive wives at the 1955
World Series victory party (left to right): Mrs. Walter (Kay) O'Malley,
Mrs. John (Mae) Smith, Mrs. Harry Hickey, Mrs. John Cashmore
(wife of the Brooklyn borough president), Mrs. James (Dearie)
Mulvey, Mrs. Fresco (Peg) Thompson, and Mrs. Buzzie (Evit) Bavasi.

In the executive box at Ebbets Field (left to right), Bud Holman, Walter O'Malley, and Captain Emil Praeger host New York governor (and former presidential candidate) Thomas E. Dewey. Mrs. O'Malley is at far right. Holman was the Florida businessman who convinced O'Malley to turn a former Vero Beach naval air station into Dodgertown. Praeger was the legendary engineer who drew up plans for Holman Stadium in Florida, worked on the Dodgers' proposed new home in Brooklyn, and, ultimately, designed Dodger Stadium in Los Angeles.

Scully—nattily sporting aviator glasses and penny loafers—chews the fat in the dugout with Gil Hodges.

VIN SCULLY: "Probably with a couple of writers, as well. It was simpler in those days, where you could sit and hang out in the dugout and shoot the breeze and then go upstairs and do the game. Especially when it was radio. [With] television, I have to be there early to get all the stuff out of the way and then tape. So this was just one of those days, just hanging out.

"Penny loafers? We always wore penny loafers, even then, I guess. I'm not sure when this was taken. Well, that's a World Series ring, so that means I've been there…this would be about my seventh year, so I'm pretty relaxed by now.

"As far as the sunglasses, I have no idea. I don't wear sunglasses a lot, and when I came out here [to Los Angeles], I was going to do a commercial. The photographer was a famous name in Hollywood, and he had married Linda Darnell, a beautiful actress. His name was Pev Marley. And I went into the studio and he hit me with these lights, and I went, 'Whoa!' And Pev said, 'When you come out here, you've got to be careful when you wear sunglasses. Don't wear them all the time because when you come into the studio, we're gonna hit you with lights.' I don't know about the sunglasses. I have no idea, nooooo idea."

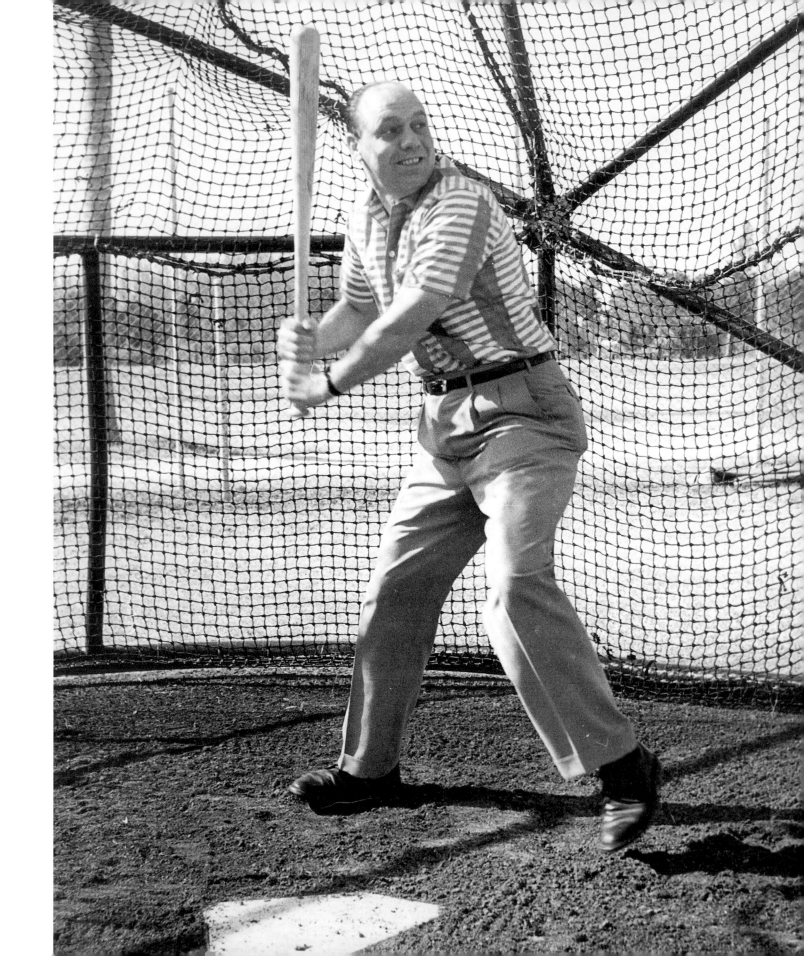

Bavasi takes a few cuts in the batting cage in Vero Beach.

BUZZIE BAVASI: "I only did that once. That was in '57 or '58. I said to [Don] Drysdale, who was very young at the time, that I wasn't too impressed with him, that I thought even I could hit him. So I grabbed a bat and stepped in. First pitch, he hit me right in the rear end. So that was the only time I did that."

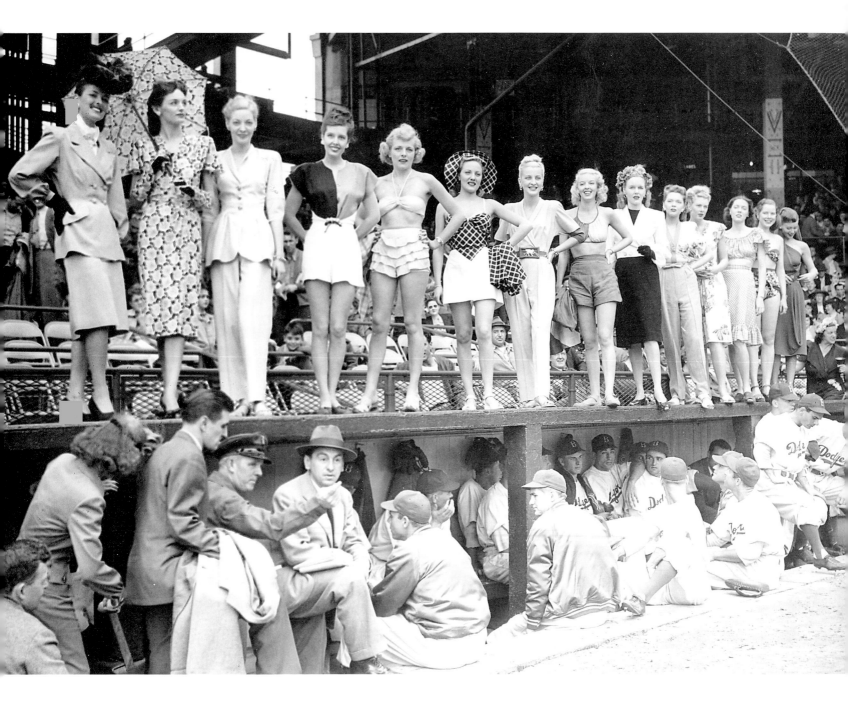

FOUR
Press Agent's Delight

Any press photographer of that era soon learned that he couldn't live on action shots alone. There was a constant search for the offbeat, the unusual, the contrived (if possible). And in Brooklyn, there was no shortage of that.

With the appropriate circumstances and subject matter, an experienced pro like Barney could instantly dream up an off-the-wall shot that would find its way into the paper the next day. The combination of the right person, the right setting, maybe a prop or two, or throw in a celebrity or politician…and bingo.

"Publicity was my business, and I knew how to get photos in the newspapers," Barney once wrote.

And if an enterprising photog needed any assistance in turning over an idea, help was there within a talented group of press agents whose job it was to keep the Dodgers in the news.

Today they'd be called public relations men, but individuals like John McDonald (in the early days), Arthur Mann, Irving Rudd, Frank Graham Jr., and, later, the legendary Red Patterson made the Dodgers a photographer's dream. With these kinds of creative folks around, a great shot was only a shutter-click away.

Having President Eisenhower, General MacArthur, and Marilyn Monroe around didn't hurt, either.

A dugout fashion show in the late '40s, in which the players seem a little too blasé. Sportswriters Arch Murray, Dick Young, and Gus Steiger are at lower left.

Marilyn Monroe kicks out the first ball at Ebbets Field for a *soccer* game on May 12, 1957, to begin the match between the American All-Stars and Israel's Hapoel club. When asked which American they would most like to meet, one of the Israeli players replied, "As athletes, we'd like to meet the Brooklyn Dodgers. As men, Marilyn Monroe."

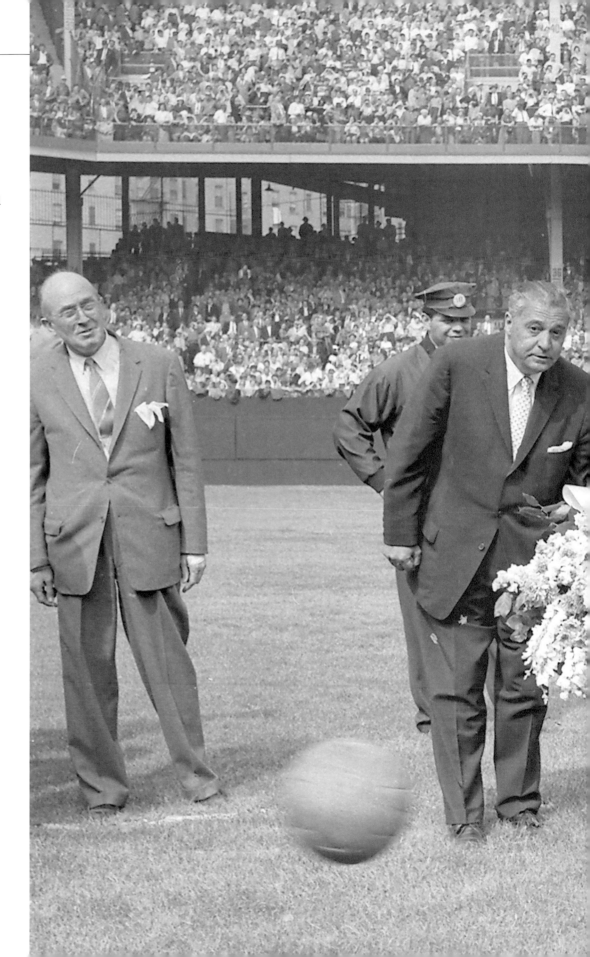

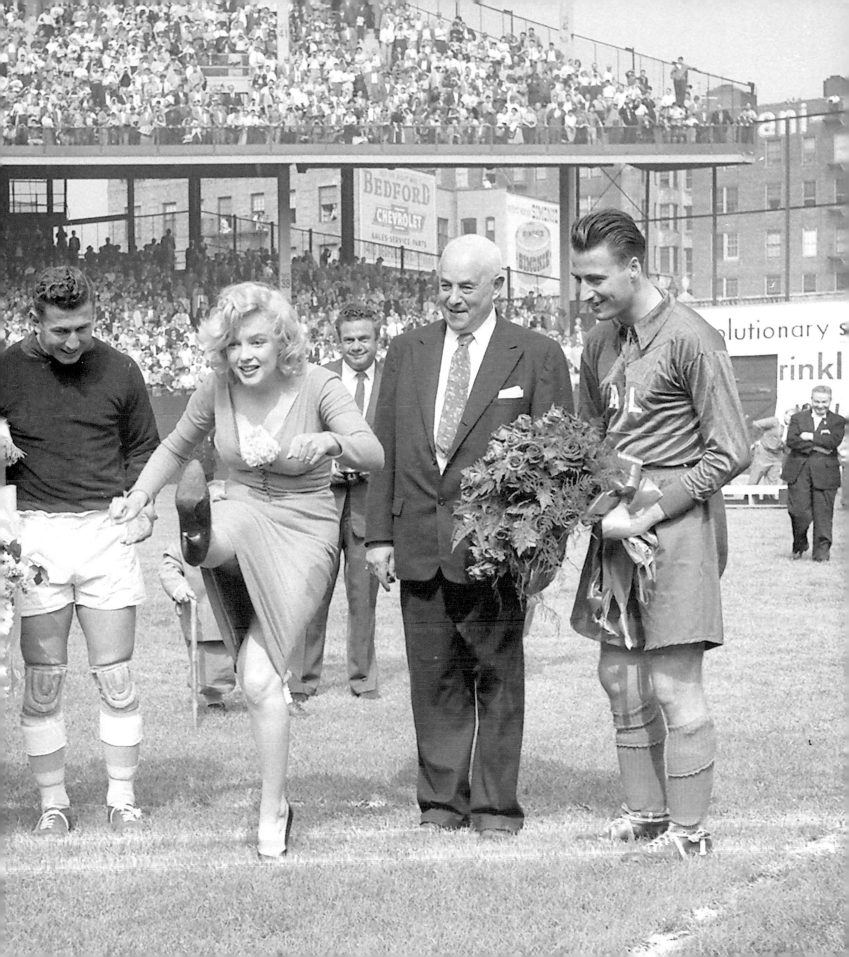

Mr. and Mrs. Frenchy Bordagaray sew things up during Frenchy's second stint with the Dodgers in the early '40s. By this time, Frenchy had gone clean-shaven, after distinguishing himself in the '30s as the last modern player to wear a mustache until Charlie Finley's Oakland A's of the '70s.

During World War II, travel restrictions forced the Dodgers to hold spring training at Bear Mountain in upstate New York. Upon arrival at the Bear Mountain Inn, Tom Warren, Howie Schultz, Luis Olmo, Frank Drews, and Hal Gregg fired snowballs at Barney's camera.

Actress Jane Wyatt, later to become Robert Young's TV wife on *Father Knows Best*, visited spring training at Bear Mountain in '45. Barney snapped her at a favorite locale (with its namesake).

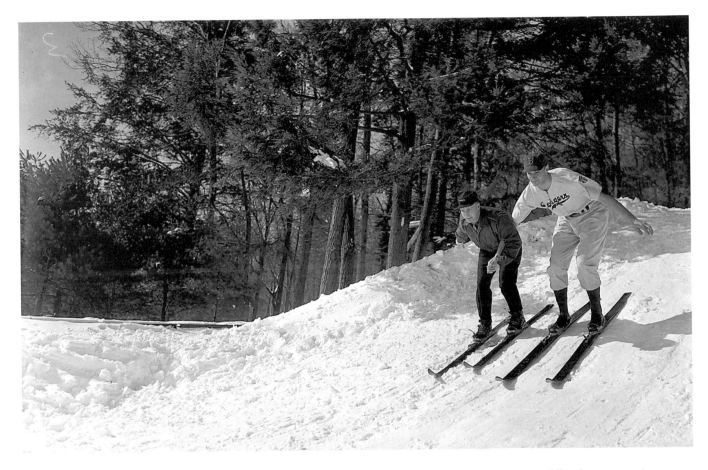

When snow fell on Bear Mountain, Barney cooked up a plan to pose several Dodgers on skis, which he undertook without manager Durocher's knowledge lest he find his players hitting the slopes at 6:00 AM. One of the surviving shots shows 6'6" first baseman Howie Schultz negotiating the hillside with ski instructor Hans Strand. "High Howie" was one of three Dodgers who also played in the NBA, along with Chuck Connors and, in 2006, pitcher Mark Hendrickson.

BARNEY STEIN: "The players put on their skis and I begged them, please, pretty please, not to get any strawberries [bruises], then Leo would really get mad at me. The players did very well and I got my photographs. The players got their land legs together, I thanked the ski master and slunk away to my underground darkroom to develop my negatives [and] dry and caption them to be sent to the various papers and syndicates by bus for the next day's publication and hope, fervently, that Leo wouldn't give me the calling down I deserved!

"What happened that same afternoon after my 'shooting' the players on skis was that the newsreel cameramen came up to ask Leo for the same idea I had. Leo replied angrily, 'No way, fellas. No way will I subject my players to get hurt....Out! Out! Case closed!' When the papers appeared the following day with my photographs, I made myself very scarce to Leo. Apparently, he liked my photographs and never reproached me. Whew!"

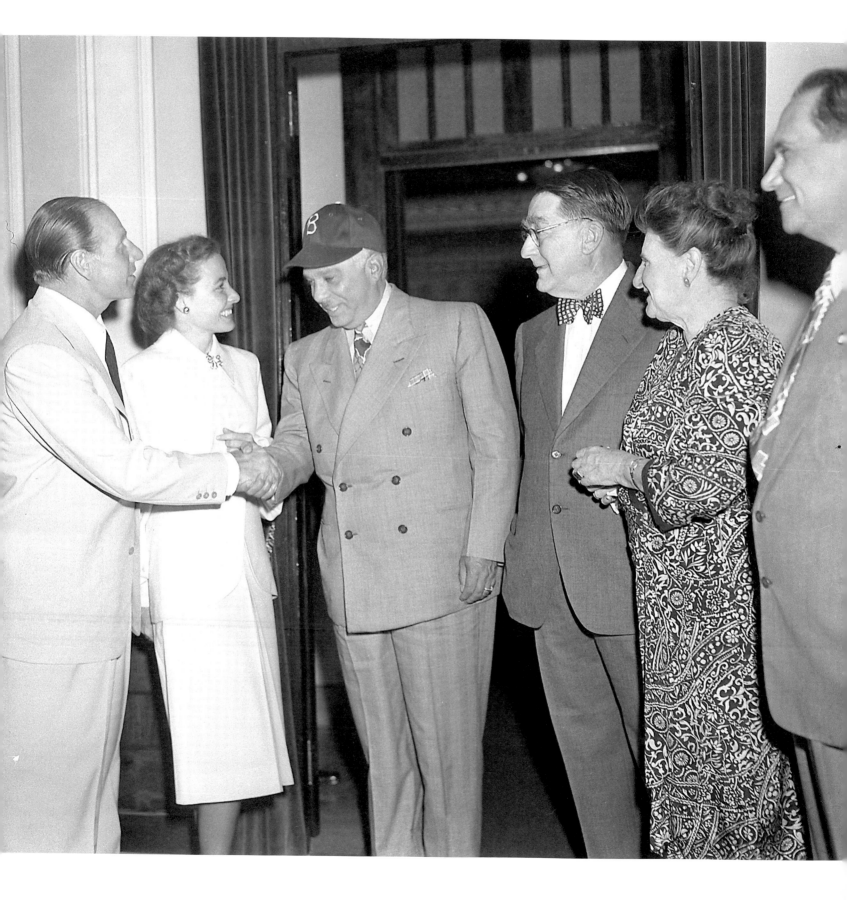

In 1948 the Dodgers trained at Ciudad Trujillo in the Dominican Republic, whereupon Barney hatched a scheme for the country's notorious head man to make a fashion statement.

BARNEY STEIN: "President Rafael Trujillo of the Dominican Republic invited Mr. and Mrs. Branch Rickey, together with Leo Durocher and his beautiful wife, Laraine Day, to the palace for an official welcome. My mind started to work as to what would make a good news photograph to send back to the States. I hit upon the idea of the president wearing a Dodgers cap greeting them. I managed to get a cap from Senator John Griffin, our clubhouse custodian. I then took Durocher aside and asked him if he would have the president wear the cap, and he replied, 'I'm not gonna ask him to do a thing like that—you ask him!' I replied, 'I think you're chicken, Leo. Sure, I'll ask him.' And just before the handshaking began I approached President Trujillo in my very much broken Spanish to don the Dodgers cap, and he happily replied, '*Si, si.*' Everyone had quite a chuckle, and I had a swell shot to send back home."

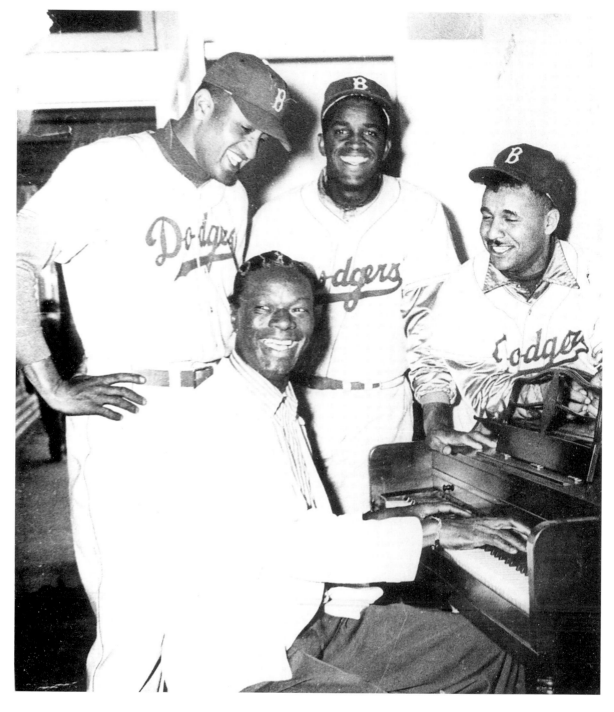

Nat King Cole gives an impromptu clubhouse concert for Newcombe, Black, and Campanella…a photo that, a half-century later, still resonates on many levels, for many reasons.

DON NEWCOMBE: "This was in Vero, and Nat was touring with his trio and he came up to our training camp to see us. I'll never forget when he came in. This had to be 1954, because Joe Black is in the picture. Nat loved his Dodgers. He had a box seat right behind home plate in the Coliseum, and every game we played in the Coliseum, he and his wife, Maria, would be there. We loved him, and Billy Eckstine, Joe Louis, Sugar Ray Robinson, Cab Calloway. Whenever they came to the ballpark, they'd sit right by our dugout, and we knew that we weren't going to have any trouble with anybody in the stands calling us names and stuff, because people respected these guys. They loved this man [Cole], they loved Joe Louis. Joe Louis would sit right behind our dugout, and nobody in Chicago called us any names with Joe there. Hey, we had protection.

"They respected what we did, they loved what we did, and what we were doing because of what they had to go through. Do you know that Nat King Cole played in Las Vegas, Billy Eckstine played in Las Vegas, and they had to come in the back door? They put them on stage, but they had to eat in the kitchen and came in through the back door. They couldn't even come in through the front door, even though they were working in Las Vegas. And not allowed to stay there, hell no.

"I remember going to Las Vegas with Johnny Podres and Don Drysdale. We were coming to Los Angeles in 1958 from Vero Beach and we stopped to play, I think, the Cleveland Indians in an exhibition game in Las Vegas. So me and Johnny and Don did our workout, and then we said, 'Let's go down to the Strip.' So we went to the Sands and they wouldn't let me play blackjack. This is in '58. The dealer said, 'I'm sorry, Mr. Newcombe, I can't let you play.' And over at the dice table was a fine actor named John Carroll. He's playing by himself, and John heard this conversation going on. And John yelled from the table, 'Goddamnit, if Don Newcombe can't play blackjack, I'm not playing any more, either!' And I wound up playing, and this came from a white man named John Carroll. And this is what opened up the doors for all these entertainers who went there. Sammy Davis, Dorothy Dandridge. Do you imagine Dorothy Dandridge sticking her toe in the swimming pool at the Riviera, and they drained the pool and scrubbed it, just because she stuck her goddamn toe in the water?

"And the problems aren't solved today. We're talking about 2006, and they're not solved yet. A lot of people think they are, but they're not. It's much more subtle now than it was then, but still you've got the problems. We were doing it before Martin Luther King; he started in 1955 in Montgomery with Rosa Parks. We were doing it in 1946. He sat at my dinner table one night and said, 'You and Jackie and Roy will never know how easy you made it for me to do my job.' And this was 28 days before he died in Memphis, in 1968. So you think it's solved? The problem's not solved.

"And Barney, taking these pictures, brings back the memories about what and how these pictures came about. Nat came up to see us, to let people see that we were friends."

South of the border in spring training 1948, Barney put Mr. and Mrs. Rickey and Laraine Day in native headgear. By the middle of that year, Laraine (and Leo) had acquired new wardrobes—that of the New York Giants, who hired "the Lip" in July after Rickey let him go.

BARNEY STEIN: "For the time Laraine was married to Leo, he taught her the game so well that she was doing interviews between games of doubleheaders, and she knew the standings and everything that went with statistics, [so] the players were at ease with her. Laraine and I got along very well. At first I was a bit awed with the famous movie actress, but she made me feel very much at home and it really was a pleasure to be in the company of such a swell gal!"

RALPH BRANCA: "We used to kid Barney because he always used to say 'Uno más,' you know. *Uno más*, I guess, he got from our trip to Santo Domingo or Cuba in '47 or '48."

Before he won fame as TV's *Rifleman*, Chuck Connors was a tall, gangly first baseman in the Dodgers system. He was good enough to play in 67 big-league games (all but one with the '51 Cubs), but his true calling lay elsewhere. Long after leaving baseball for Hollywood, Chuck would return to Vero Beach to entertain his old teammates with a stand-up routine that included a recitation of "Casey at the Bat."

BUZZIE BAVASI: "This is in Vero Beach. Chuck played for me in the minors and he was a first baseman. Not a bad ballplayer, but he knew what he wanted to do all along. He wanted to be an actor. So we sent him out to Los Angeles [to the Pacific Coast League], where all the agents were out there, and we did him a big favor because now he was close to all the people he wanted to be with. But every year at our annual St. Patrick's Day party, we'd bring him in to recite 'Casey at the Bat,' and he was good at it."

DON NEWCOMBE: "Chuck and I were teammates in Montreal. Chuck fought a fight for me in Syracuse one night when the Syracuse Chiefs' catcher charged the mound and jumped up in my face with his spikes and was going to grind my black face down in the mud. But he didn't know that I knew more about getting out of the way than he did about jumping up in my face with his spikes. He ran by me after he jumped up in my face—I had side-stepped him—and Chuck met him at second base and kicked the shit out of him. Next day Chuck had two black eyes and a busted mouth. Chuck had said to the guy, 'He can't fight you, but I can!' This was in 1948, when I couldn't fight back.

"Chuck had a thing for telling stories, he had card tricks, and Chuck even did a command performance in spring training down in San Cristobal, Santo Domingo, when we were with Montreal. Branch Rickey had him come to Trujillo City with the Dodgers and had him do a command performance for President Trujillo with his card tricks and 'Casey at the Bat.' So Chuck was quite an entertainer."

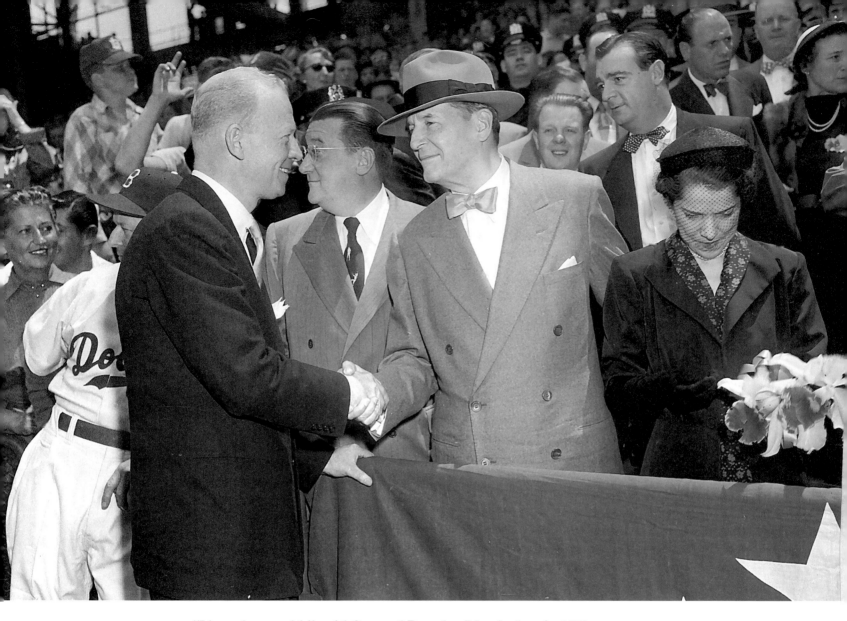

"I have been told," said General Douglas MacArthur in 1951, "that one hasn't really lived until he has been to Ebbets Field." So the Dodgers arranged to have the five-star general as their special guest soon after he'd been controversially shorn of power by President Harry Truman. The general—seen here shaking hands with announcer Red Barber with Walter O'Malley in between—had such a good time that he eventually became an Ebbets Field regular, receiving a gold lifetime pass from O'Malley. Dodgers press agent Irving Rudd (directly over MacArthur's left shoulder) engineered the general's visits but ultimately blamed MacArthur (and not Bobby Thomson) for the team's legendary collapse…since the Dodgers went 0–13 in the games Mac attended in '51!

Walter O'Malley greets 17-year-old King Faisal II of Iraq in the Ebbets Field press room on August 13, 1952. Irving Rudd (far left) does the presenting. Attending his first major league game, the king joined O'Malley in the president's box for the Dodgers' doubleheader split with the rival Giants. Six years later, the young king would be assassinated.

The photographers join the players for fishing in Vero Beach in '51. The photogs are Barney (lower left), Herbie Scharfman (standing, second from left), and Harry Hirsch (standing, far right); the players are Newcombe (standing, far left), Campanella (standing, second from right), along with...

DON NEWCOMBE: "That's Jim Romano [lower right], that's Tommy Brown [seated middle, with pipe], and that's Steve Lembo [standing, middle]. That's about the only thing we could do together in Vero Beach, and that's in spring training. The only thing we really could do together was go fishing. We couldn't play golf, they wouldn't let us. Roy didn't play [golf], me and Jackie did, but they wouldn't let us play. That's why Mr. O'Malley built the golf course down there, so we could play somewhere. He said, 'You won't let them play in Vero Beach, I'll build my own golf course.' And that's what he did."

One of the Dodgers' most ambitious promotions was Pee Wee Reese's 37th birthday party, held before a packed house at Ebbets Field on July 22, 1955 (one day before Pee Wee's actual birthday). The Dodgers captain was showered with gifts, including a brand-new Chevrolet, the keys for which were picked out of a fishbowl by Reese's daughter Barbara amid those from seven cars. The climactic moment came when the Ebbets Field lights were turned off, cueing the fans in the darkened stadium to light matches and sing "Happy Birthday" to Pee Wee. The dramatic "lights-out" effect would be repeated four years later when the now–Los Angeles Dodgers honored a paralyzed Roy Campanella at the Coliseum.

BARNEY STEIN: "The most dramatic baseball photograph I made at Ebbets Field was on Pee Wee Reese's birthday at a night game with the Milwaukee Braves, when the fans were asked to light matches when the lights were out and all the fans shouted, "Happy Boithday, Pee Wee!" Roy Campanella was standing at home plate with his arms around Pee Wee! I choked back my tears when I made my time exposure. All this happened to the most liked Brooklyn Dodger player—Captain Pee Wee."

BUZZIE BAVASI: "The fans chipped in, and we gave him a nice car. The next day Pee Wee comes in to me and says, 'What do I do with *this*?' See, the Brooklyn fans gave him the car and made the first payment. Then Pee Wee gave me the bill for the rest of it, so help me."

President Dwight Eisenhower throws out the first ball for Game 1 of the 1956 World Series at Ebbets Field, flanked by Yankees manager Casey Stengel and Dodgers skipper Walter Alston. Looking on (left to right) are Secretary of State John Foster Dulles (far left), Major John Eisenhower (the president's son, behind Stengel), Secretary of the Treasury George M. Humphrey, Dodgers president Walter O'Malley (behind the president), and baseball commissioner Ford Frick. It was the first appearance for a sitting president at the Series since Franklin D. Roosevelt attended the 1936 Classic between the Yankees and Giants.

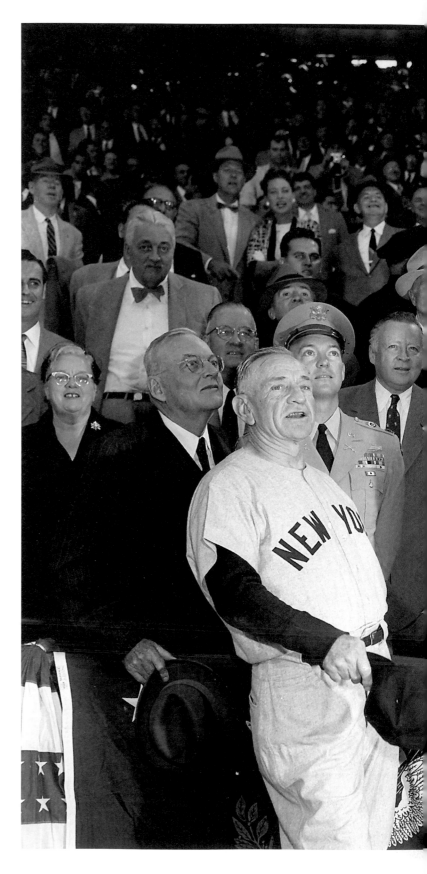

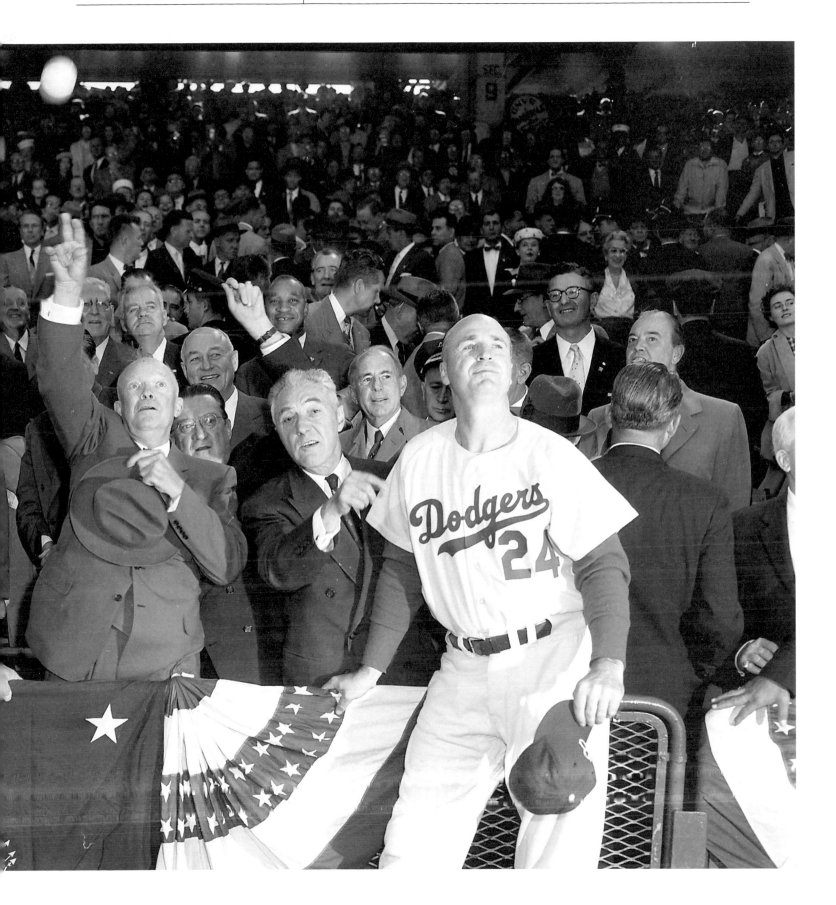

Dodger Blue one year, navy blue the next. Just months after his World Series heroics, Johnny Podres was called into the navy and missed the entire 1956 season. On Opening Day, he stopped by just long enough to pick up his Series ring and swap headgear with batterymate Roy Campanella.

JOHNNY PODRES: "I remember coming there for Opening Day, hoping I could be pitching that day, but I wasn't! I went to spring training [in 1956], and then they reclassified me and I went into the service in late March. After I did my boot training, I came back to Brooklyn once in a while. I was stationed in Norfolk, Virginia, and I'd get the weekends off a lot. I tried to get a couple of dollars off Buzzie to survive for a month. I pitched batting practice a little, because I was pitching in the service.

"Ted Williams said at the time that if I hadn't beaten the Yankees, they never would have reclassified me. It was all public pressure, I guess. How can I be winning two games against the Yankees and not be in the service? Well, I had taken my physical in 1952 and I couldn't pass it, and they made me 4-F. Then when I beat the Yankees, they reclassified me. I guess it was pressure. And you can't blame the families. Why should I be pitching and their children be in the service?

"You know what's really something? I beat the Yankees in the seventh game in '55, 2–0. In my first start back after coming out of the service, I beat Pittsburgh, 2–0. That was more than a year later."

Gil Hodges Night was held on July 19, 1957, as the native son of Indiana was honored by family and friends in his adopted Flatbush. There were cars, gifts, speeches, and a kiss on the cheek for baby Cynthia from her proud papa.

JOAN HODGES: "We had about four Gil Hodges Nights, you know [over the course of Gil's career]. It was a great night, it really was. I forget the car we got [that night]. I know one year we got a Studebaker, a white Studebaker given to us by [Bohack Supermarkets in 1962]. But the car here, I have no idea where it went. Maybe Gil sent it to his brother, I'm not sure. I think we might have gotten a total of four cars, on every one of those nights. But that was quite a special night, and Cynthia, of course, was the youngest one there."

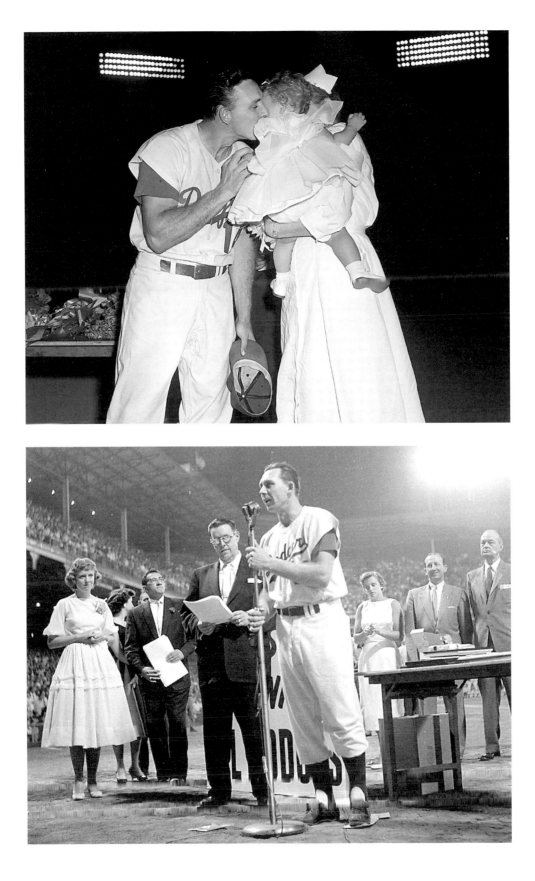

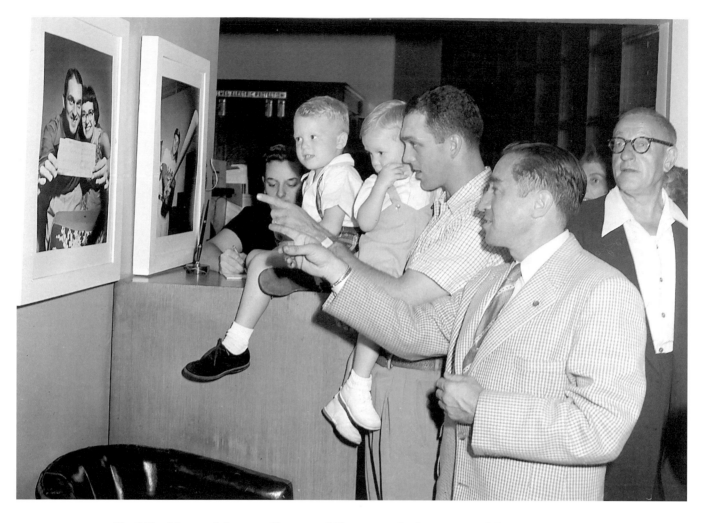

Carl Erskine, with sons Gary and Danny, admire some of Barney's handiwork.

CARL ERSKINE: "My recollection is this: that Barney took us to this art studio of Ham Fisher, who was the creator of *Joe Palooka*, the comic strip. That's what I remember, vaguely, about this art studio. These are Barney's pictures on the wall. The picture he's pointing to is me and Betty with the bonus check from my first no-hitter. It was $500, I remember that. We knew Ham Fisher because he had drawn a picture of Joe Palooka for my boys, signed it to Danny and Gary and all that. The fact that Barney's pictures are on the wall makes me wonder if this was some kind of exhibit for him, he might have had a showing someplace."

Gorgeous Gussie Moran, the tennis star–turned-sportscaster, monitors the racquet work of (left to right) Don Zimmer, Duke Snider, Carl Erskine, and Walt "Moose" Moryn in '55.

CARL ERSKINE: "Do you know what gold lamé is? Gussie Moran became world famous for wearing her panties with gold lamé at Wimbledon. This is just a staged shot at Vero Beach. I would take this to be in Holman Stadium because of the outfield fence, the way it's mounted up there. Walt Moryn? Yes, that's who I thought it was. Let's see, it's Duke and me, and who's the other one? Zimmer? That's who I thought it was. I've got it written down here."

DUKE SNIDER: "Moryn's up in the air pretty good, isn't he? I remember her coming to spring training and us taking this picture. That's Holman Stadium and it's changed quite a bit from the way it looks now. She was a very nice lady, and they brought in the racquets and we posed. This is an interesting shot. I've seen this picture before, but I don't remember Moryn getting up that high!"

VIN SCULLY: "She was on the pre- and postgame radio show and she came down to Vero. She was very outgoing, and we had a couple of minor league managers who wanted to go out with the outgoing."

In the days before "celebrity fans" became the norm, the Dodgers had two who followed the team on both coasts: Danny Kaye attends a World Series game with Leo Durocher and Laraine Day, while (right) a three-handed Milton Berle clowns with Leo during wartime spring training at West Point.

BUZZIE BAVASI: "Danny was a fan. I think Milton may have come to the games just to be seen, but he was still there at least 20 or 30 times a year. Danny was a real fan. [When we came to Los Angeles], Danny had the key to my private box. He'd sit there by himself, eat peanuts, and dirty up my floor. Danny was just a great fan and a great person."

VIN SCULLY: "Danny was a huge fan, a very knowledgeable fan. In fact, he got a small ownership of the Seattle Mariners [in 1977]. Huge fan. And Leo, of course, was Leo.

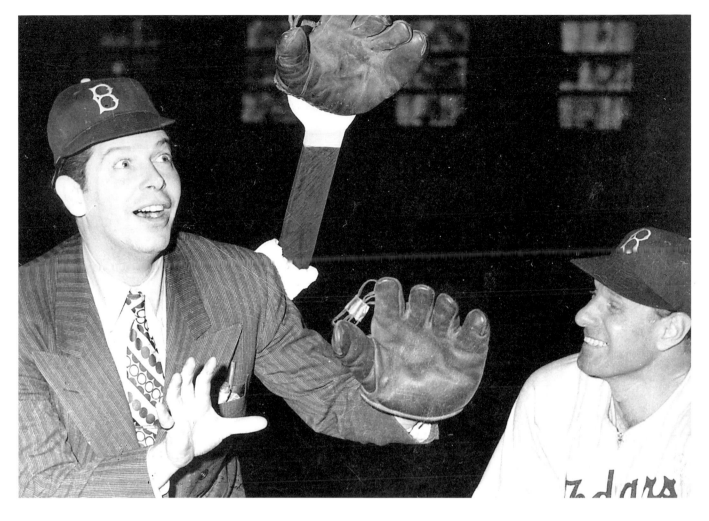

"Danny was extremely bright. We were very good pals. Danny was a gourmet chef, and then he decided to be a Chinese [food] specialist, and he went to China to learn to cook. And then at his home in Beverly Hills, he added on a Chinese kitchen, with these huge woks and everything. When he cooked, being the artist that he was, he was always on stage, and his guests would sit at these dark lacquered tables, and he was followed by two ladies. He would use everything, and by the time he was finished, nothing was dirty. The ladies just followed him.

"He was very bright in medicine. He was also a licensed pilot, and he could fly almost anything. He was a superb, almost a scratch golfer; then the game lost its challenge and he gave it up. But he was a renaissance man and then some."

Pee Wee and Dottie Reese at their kitchen sink. On the back of this print were written the words "Barwell Terrace," the Reeses' street address in Brooklyn.

JOAN HODGES: "I remember Dottie [Reese] being very, very close with Betty Erskine, Millie Walker, and Bev Snider. They lived together over here in Bay Ridge, and their husbands would go in together and so on, and they were avid bridge players. They all lived in Bay Ridge, never lived anywhere else. They all had the same doctor, Dr. Steiner, the pediatrician."

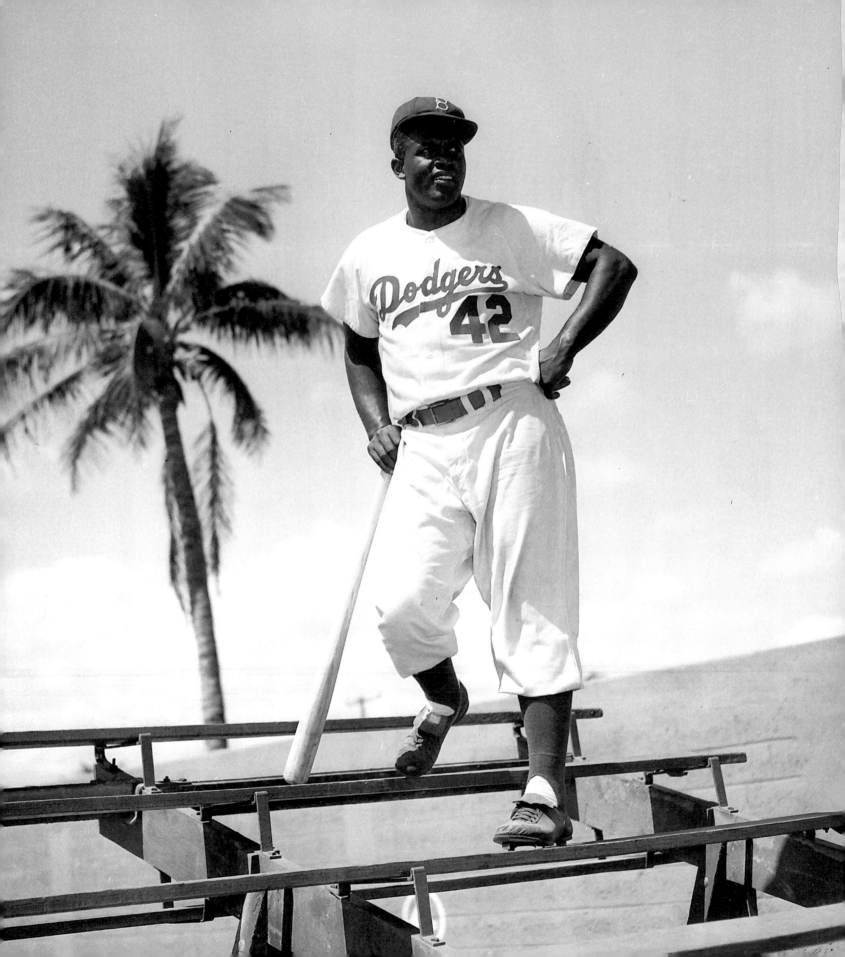

FIVE

No. 42

Jackie Robinson's legacy as a ballplayer, and as an American, resonates to this day.

As the first modern African American major leaguer, Robinson's tenacity, fearlessness, and competitive spirit stamped him as one of the game's greatest players from the moment Branch Rickey chose him to break baseball's color barrier in 1947. Away from the diamond, Robinson became a lightning rod for social change and a pioneer in the burgeoning Civil Rights Movement.

It was this man who was, unquestionably, Barney Stein's personal favorite among all the Dodgers. The relationship between the athlete and the photographer, and their families, was one of deep respect and admiration, which only grew stronger with the passage of time.

Many of Barney's photos of Jackie reflect that closeness. The man the world knew as an athletic icon, Barney Stein was proud to know as the best of friends.

On a sun-kissed Florida day, Barney captured a relaxed Jackie Robinson in spring training.

Of the hundreds of pictures Barney took of Jackie, this is one of the first. It's spring training 1947, and Jackie is on the bench with his Montreal Royals teammates a few weeks before he was called up to the Dodgers. When this photo was presented in *The Rhubarb Patch*, Red Barber wrote that "it was snapped without warning. You couldn't pose this one. This is an early exhibition game. Against the background of the Deep South, Robinson sits on the Royals' bench, his uniform not even matching those of his teammates. What is he watching as he sits there? What is he thinking? I don't know what he's thinking, except that I know Jack, and I'm sure he isn't wishing he hadn't plunged into it."

BARNEY STEIN: "In 1947, I was told by Harold Parrott to go to the Montreal Royals' training site to get a picture of one Jackie Robinson, a promising rookie who could hit, steal, and practically do anything on the diamond. I figured he was going to be the first Negro to play in the major leagues. When I got through with my pictures I said to Jackie that I had a hunch he would join the parent Dodger club before long, and he told me he wished it would come true. In less than a week his wish had come true, and I playfully said to him 'I told you so!'"

Leo Durocher would have been Jackie's first big-league manager, had he not been suspended for the '47 season by Commissioner Happy Chandler. This shot is from spring training '48, upon Leo's return to the Dodgers.

Taking a lead off first against the Cardinals before a packed house, August 1955. The first baseman is Wally Moon.

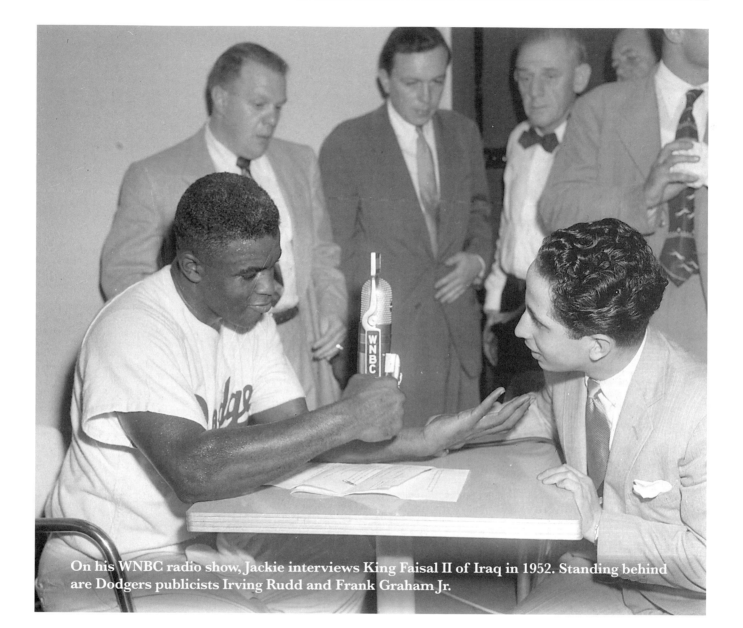

On his WNBC radio show, Jackie interviews King Faisal II of Iraq in 1952. Standing behind are Dodgers publicists Irving Rudd and Frank Graham Jr.

CARL ERSKINE: "Jackie was very confident, once he got established. He did a column in the papers, he did a radio talk show, he spoke who knows how many times. I went with him to schools many times, and he was always very articulate. You know, he testified before Congress, back when communism was a big topic and we thought we were being infiltrated at all levels. Of all the Dodgers, he's probably the one, and Pee Wee maybe, where it would be a no-brainer for him to meet someone in a high place.

"I kind of halfway know the guy in the bow tie, but I can't think of his name. I just see him and remember him, but I can't place the name."

Jackie's radio program hosted a wide range of personalities, from slugger Ralph Kiner to Barney Stein. That's Ralph Branca to Jackie's left in the photo with Barney.

One of the signature moments in Robinson's career: his daring steal of home in Game 1 of the 1955 World Series at Yankee Stadium. Catcher Yogi Berra argued the call with umpire Bill Summers but to no avail. Pinch-hitter Frank Kellert is the batter, as Jim Gilliam and batboy Charlie DiGiovanna watch from the on-deck circle. Half a century later, this remains the last "straight steal" of home (not part of a double steal) in World Series history.

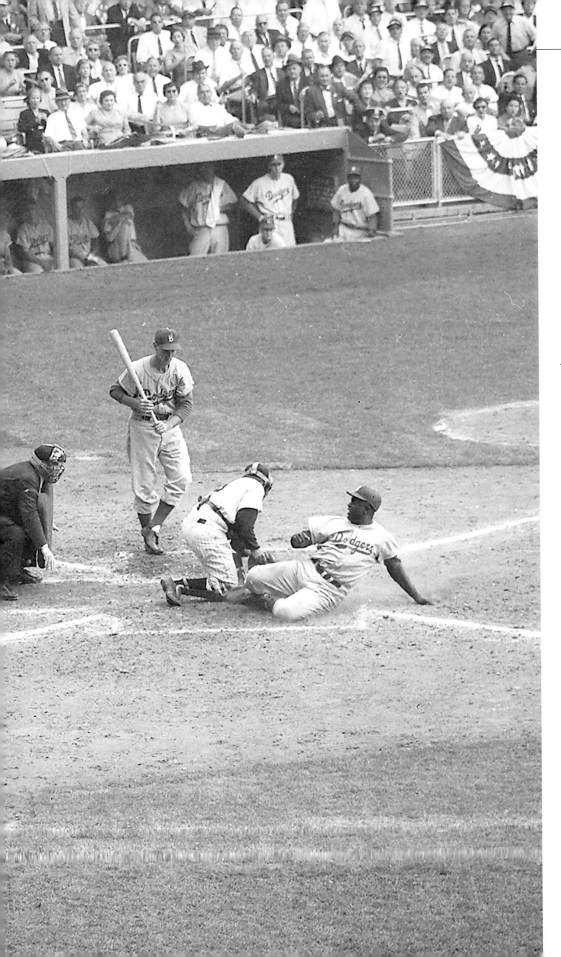

CARL ERSKINE: "Game 1, '55 Series, Jackie steals home off Whitey Ford. This play, of course, has been reworked over by everybody. We all agreed Jackie was safe, as did Bill Summers, the umpire. There's only two people in this world that I've ever heard say that Jackie was out. One of them was Yogi, and the other was Frank Kellert, the guy standing there with the bat. And Jackie wanted to kill him! After the game, the writers said to Kellert, 'You had the best view of anybody, including the umpire.' The umpire's blocked out a little bit by Yogi. But Kellert's looking straight down at the tag, and when they asked Kellert, he said, 'I thought he was out.' I'm telling you, Jackie wanted to choke him. He just gave an honest answer.

"I've seen that play over and over, and I'll tell you, it's hard to tell. Except that Jackie didn't give him anything to tag. His toe went across the black part of home plate, and he just nipped the corner of it. Anyway, it's in the book as safe, and that's the way it'll always be."

Best friends Jackie and Pee Wee Reese weathered many an on-the-field storm during Robinson's early years. Here's a lovely shot of their wives, Rachel Robinson and Dottie Reese.

When it came to Jackie, Barney often found himself on both sides of the camera. Here he is in spring training 1951 and also posing (with wife Ruth) with Rachel and Jackie.

BUZZIE BAVASI: "Barney was Jackie's biggest fan. Barney never took or published a picture of Jackie, or gave away a picture of Jackie, without Jackie's permission. Of all the people in the media, he and Jackie were the closest. The 'No Vacancy' sign was Barney's way of saying that second base was Jackie's and that nobody else would play there. They were really good friends. As a matter of fact, it surprised me that Jackie was that friendly to anybody [in his early Dodgers years], because he had to watch his step. But he and Barney were real friends."

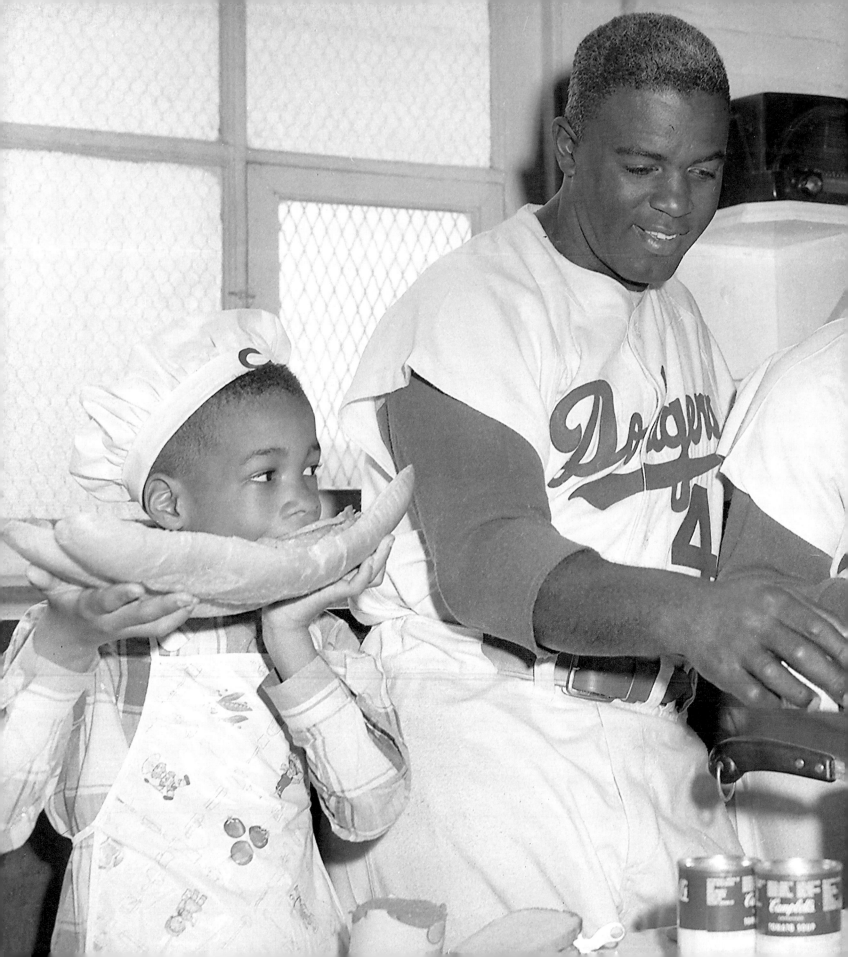

Jackie and Pee Wee test their culinary skills—with a little help—in spring training.

CLEM LABINE: "Barney was a family man. He loved the families that the Dodgers had. He was always, in some respect, photographing the children. He certainly did it for me, with my twins and my son."

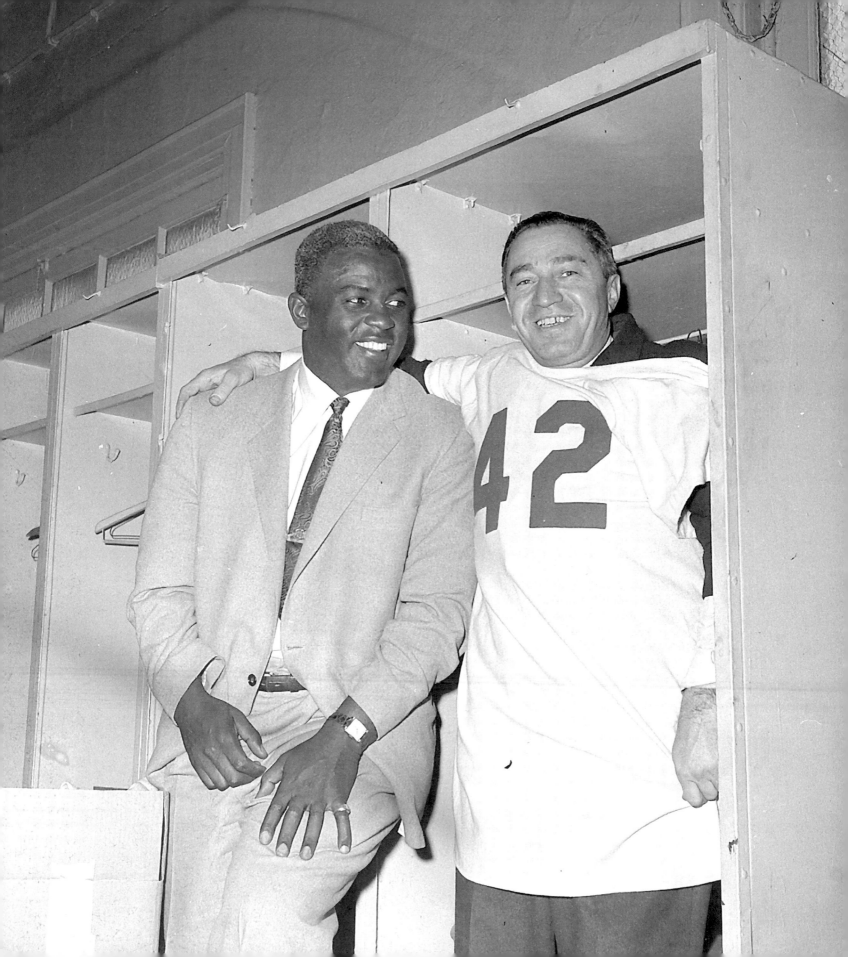

Jackie was traded to the Giants in December 1956, but announced his retirement one month later in an article in *Look* magazine. Robinson stressed that he'd already decided to retire prior to the trade, but nonetheless his unorthodox announcement caused a major stir at the time. It did nothing, however, to weaken the bonds between two men who had shared a wonderful friendship. This shot was taken on January 18, 1957, when Jackie visited the Dodgers locker room soon after the *Look* retirement story broke.

CARL ERSKINE: "He had told the club, 'If you ever trade me, it has to be with a New York team or I'm not going to go.' So Buzzie said that's why it was the Giants. But they should never have traded Jackie. He should have been like Ted Williams is with the Red Sox, Stan Musial with the Cardinals, Joe DiMaggio with the Yankees. For them to do that, it was such an undignified thing to do to a man who had brought so much to the club."

BARNEY STEIN: "When I said good-bye to Jackie Robinson, there was a smile on his face, and, quickly, I asked him to pose with me wearing his '42' shirt and he replied, 'Barney, that's the nicest thing you could ask of me.' I treasure that photo always."

SIX
Brooklyn, USA

In the 1940s and '50s, Brooklyn, New York, was a world unto itself.

And Brooklyn knew it.

It was where everyone you met, it seemed, was from. It was the stepchild of glamorous, teeming Manhattan (always referred to as *the city*), and that made it the source of a million jokes and comedy routines. Could Red Skelton have made a movie called *Whistling in Cincinnati*?

It was Ralph Kramden and William Bendix and Leo Gorcey. It was an us-against-the-world (pronounced *woild*) attitude. One of five boroughs, it was bigger and more heavily populated than all but a handful of cities in America.

It was a newspaper called the *Eagle*, and stoopball, and egg creams, and Coney Island, and thousands of immigrants who had arrived at the turn of the century and gave the place a blue-collar, down-to-earth flavor unmatched anywhere.

The face(s) of Brooklyn, USA.

DUKE SNIDER: "They usually had a cake or something that they were giving to somebody on their birthday or something. And we'd go over and have our picture taken with them and take the cake into the clubhouse and everybody would have a piece of cake. That's the way it was. They'd bring those little signs and come out and they were all a happy and very caring group. We looked forward to those little occasions like that."

RALPH BRANCA: "The fans were very, very knowledgeable and eminently fair. Hell, they'd give standing ovations to Stan Musial after he'd killed us. One time he came in and in three games he got 11-for-15. How's that?"

And, for that time, Brooklyn was the Dodgers. Above all, it was the Dodgers.

When Ebbets Field opened in 1913 in a section formerly known as Pigtown, it became Brooklyn's greatest and most famous public gathering place. And later, when the postwar Dodgers became one of baseball's elite teams, it gave the borough an unrivaled civic asset and rallying point.

Barney Stein, an immigrant son of Brooklyn by way of Russia, used his camera to record virtually every physical aspect of Ebbets Field, from the rotunda to the scoreboard to the clubhouse. More important, he captured the people and events—and the spirit—that made it so special and unique.

Today Brooklyn lives on, that same spirit enabling the borough to thrive in ways, artistically and commercially, undreamed of in the Dodgers days. And yet, half a century later, Barney's images recall a time and place— Brooklyn, USA—that will never be again.

"Meet me in the rotunda!" Tucked just inside the home-plate entrance to Ebbets Field was the unique and ornate marble rotunda. Tiled in Italian marble and topped by a domed ceiling 27 feet high at its center, the rotunda featured a 12-armed chandelier designed in a ball-and-bat motif, as well as 14 ticket windows. If you look closely at the far right side of the photo, you can make out the "EB" in the "Ebbets Field" legend that was inlaid in blue tile on the rotunda floor.

"You can't tell the players without your 15¢ scorecard!" (This shot
was taken in the final Brooklyn season of 1957.)

At your friendly Ebbets Field souvenir stand, you could buy anything from a 75¢ pen-and-pencil set to the sheet music to the *Follow the Dodgers* theme song to a (horrors!) New York Giants pennant to a copy of Barney's *The Rhubarb Patch*.

Originally—in the early '40s—they were simply called the Brooklyn Dodgers Band, a few guys from the neighborhood who sneaked some instruments into Ebbets Field and got loud. Then Red Barber named them the Sym-Phony, and their status soon became one of legend. In 1947, Spider Jorgensen and Bobby Bragan posed with some of the band's original members (left to right): Jerry Martin (snare drum), Brother Lou Soriano (trombone), Phil Caravalle (trumpet), Paddy Palma (base drum), and JoJo Delio (cymbals). Shorty Laurice, who became synonymous with the band, died suddenly following the 1948 season. That same year, in a testament to their fame and notoriety, the Sym-Phony performed at the Republican National Convention in Philadelphia.

The Ebbets Field press box—which stretched under the lip of the upper deck behind home plate—was built in preparation for the 1941 World Series, and became the permanent writers' quarters a year later.

VIN SCULLY: "That's Roscoe McGowen right here, walking toward you with the hat on. Roscoe was with *The New York Times*, and everything about him spoke of the *Times*. He was immaculately dressed. In fact, the writers in those days all dressed well, as you can see here. Today, it's very relaxed, it's casual every day. But in those days, no, they all dressed. And Roscoe dressed to the T. I used to love sitting in a [train] roomette with Roscoe, who might be sipping a little bubbly. He could recite poetry; oh, he was just marvelous."

Meanwhile, the previous press area—one level below—was eventually converted into broadcast booths and private boxes. Ironically, when Ebbets Field opened in 1913, it didn't have a press box at all.

This shot was taken during King Faisal II's visit in August 1952. Walter O'Malley and the king can be seen between the "9" and the Iraqi flag, which has since changed design. Broadcaster Connie Desmond, working the channel 9 telecast, sits between the "W" and "O."

VIN SCULLY: "We were here [to the left] with radio and television. Then this [to the far right] was Walter O'Malley's booth. So in there, among other people over the years, would be Douglas MacArthur and Dwight Eisenhower; that's where they wound up. And it was small and crowded, but it was all we knew...and it worked. I'm just trying to figure...there's a camera [above the 'R'] so there's the TV booth, and radio is right there [next to it, far left] and there were just connecting doors that went all the way down."

The fabled right-field scoreboard was installed in 1931. The Schaefer beer sign—with its neon "H" and "E" that signified hit or error—was added in 1948 (the "Schaefer awards" player name banners on the side of the board would be sold at the 1960 Ebbets Field auction). Clothier Abe Stark's famous "Hit Sign, Win Suit" offer was an Ebbets staple for nearly 30 years. The publicity and notoriety Abe gained through the sign helped lift him into local politics, including an eight-year term as Brooklyn borough president (1962–70).

Raymond Fadden was the man inside the board over the park's last two decades, working every Dodgers home World Series game from 1941 through 1956. Appearing as a contestant on TV's *What's My Line?* during the 1955 Series (Dorothy Kilgallen correctly guessed his occupation), Fadden was asked how demanding and nerve-wracking a World Series could get. "It's a cinch on a single game," he replied.

When this picture was taken, Ebbets Field had exactly one game left. Barney snapped it following a 7–3 victory over Philadelphia on Sunday afternoon, September 22, 1957—the next-to-last home game in Brooklyn Dodgers history. Don Drysdale bested Robin Roberts, going all the way on an eight-hitter, while Duke Snider smashed two home runs, the final homers hit at Ebbets Field. In the upper right corner of the board, "Pitts. here Tues. nite" heralds the next game…which would turn out to be the *last* game.

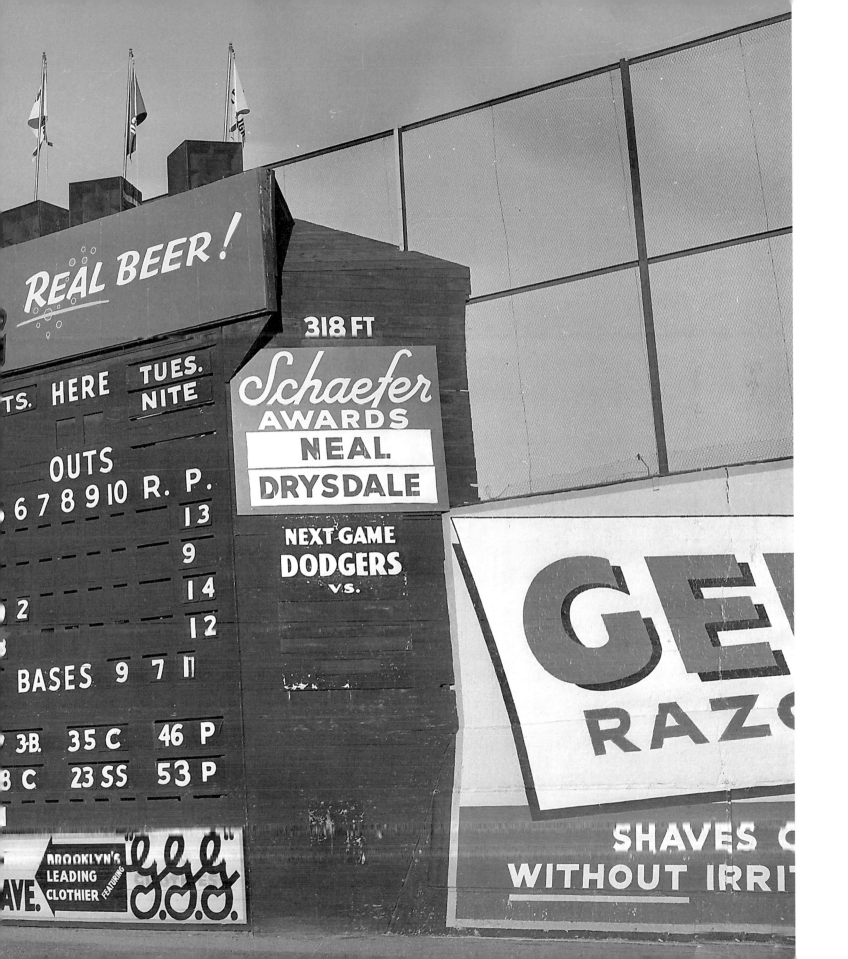

In 1953 Pee Wee Reese was included in the Gem Blades ad on the right-field wall. Of course, it was only a matter of time until…

CARL ERSKINE: "I don't know who did it. I do kind of remember it, though. But I don't know if they left it up very long or if they went out and painted it over. I don't know who did that. Pee Wee wasn't ticked off. He had his picture taken by it. He wouldn't have done that if he was unhappy about it.

"You know, the ground crew, the special cops, the ushers, the ticket takers, we knew all those people. We played together for a decade, and so we were friends with all these guys. It had to have been someone with a ladder because I don't think Pee Wee or anybody his size could have reached that high. Pretty cute."

With America newly at war, Barney captured two anonymous sailors at a 1942 game before a packed house. As Red Barber wrote in *The Rhubarb Patch*, "Who are the two sailors? How final were their farewell waves?"

A bewhiskered Red Skelton (center) poses with members of the "Battling Beavers" during the filming of the 1943 MGM comedy *Whistling in Brooklyn*, much of which was shot on location at Ebbets Field. Dodgers Leo Durocher, Hugh Casey, Arky Vaughan, Joe Medwick, Dolph Camilli, Augie Galan, and Bobo Newsom all had cameo roles in the film, as did superfan Hilda Chester.

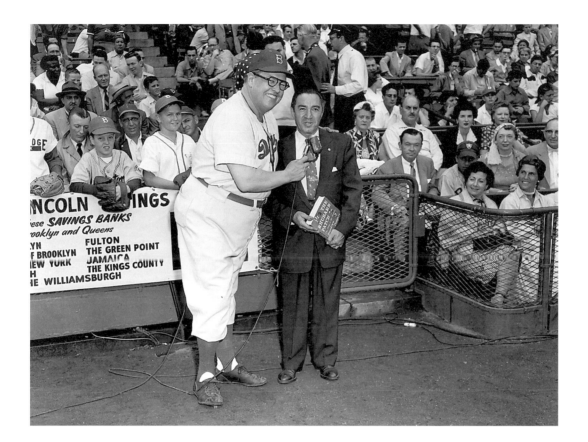

It was every Little Leaguer's dream to appear on *Happy Felton's Knothole Gang*, the show that preceded Dodgers home telecasts on channel 9 and gave youngsters the chance to play before their Dodgers heroes. Felton, who died in 1964 at age 56, took time out in '54 to interview Barney about *The Rhubarb Patch.*

VIN SCULLY: "Happy Felton was bigger than life. He had been a band leader, he had been in the movies, he'd been on radio and television. He sold the idea of a show with children before the game, where every kid would write in, and they'd select three kids. Then they'd have a player, let's say Pee Wee Reese, and have three kids go down the right-field line with Pee Wee. And Pee Wee would throw the ball on the ground to each one a couple of times, and then he'd throw the ball up in the air a couple of times, and eventually one of the three would be the winner. And then that little kid would select the player he wanted to meet, and now here comes the player. In those days, even though we televised, there seemed to be a huge barrier between player and fan. Maybe the world has changed, but kids would just look up adoringly at these people like they were not of this world. And to see a little boy ask for Jackie Robinson and have Jackie come down, or big Don Newcombe, I mean, it was a terrific show.

"But Happy was bigger than life! A big man who was a very good dancer, loved to party in every dimension imaginable. The players loved him because he was so gregarious. Oh, yeah, he was huge. Then he had a post-game show where he'd have a player on, and fans could call in with a baseball question or a rules question, and the player never knew the correct answer…and neither did Happy. He was a very, very, upbeat guy."

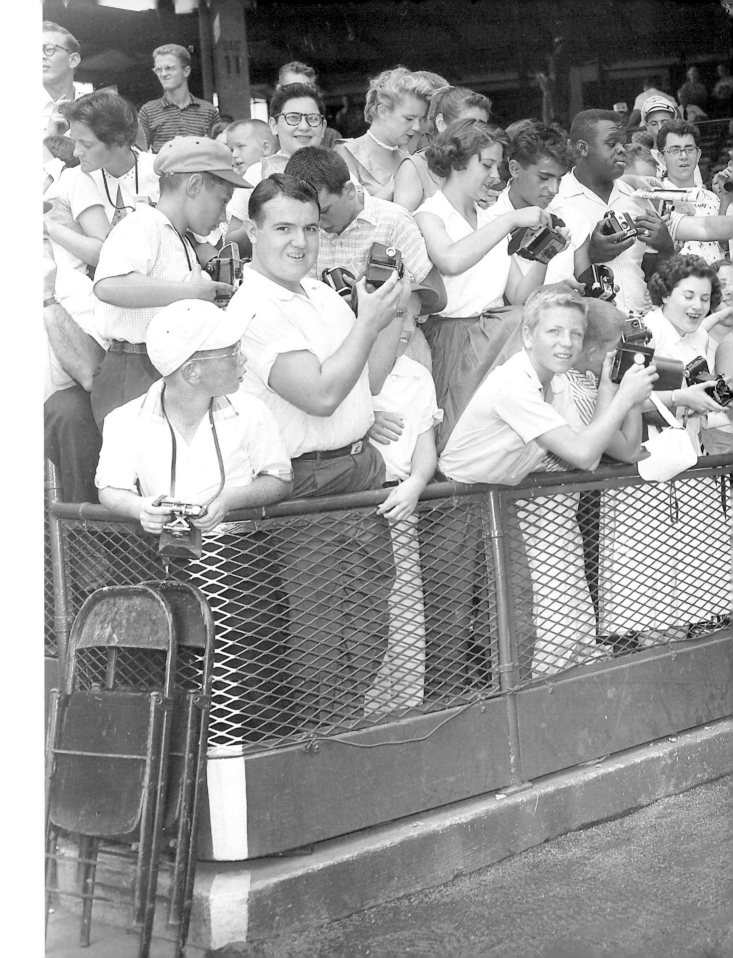

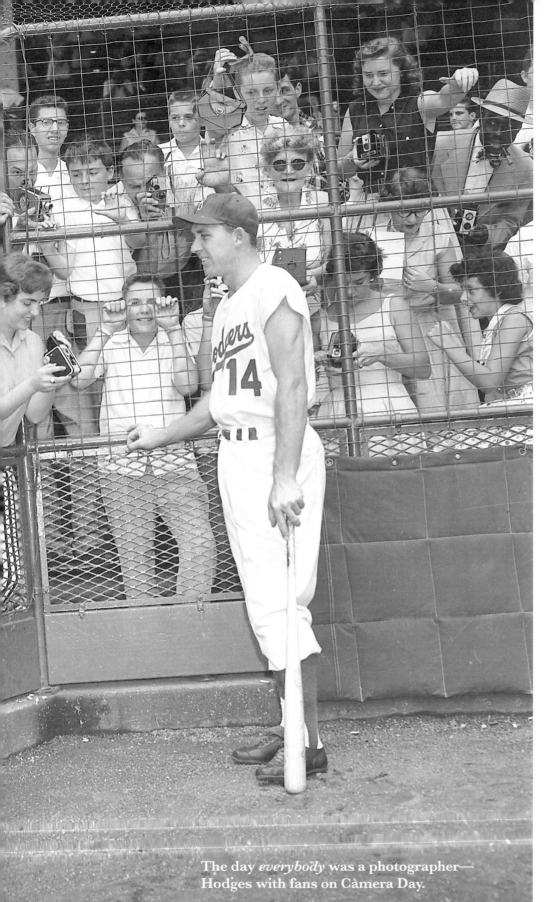

The day *everybody* was a photographer—
Hodges with fans on Camera Day.

VIN SCULLY: "One of the big differences in those days [was] you were aware of the fan. Not fans; you were aware of *individual* fans. The intimacy of the ballpark, et cetera. Today, you're aware of this huge throng, but you're not aware of individuals. At least I'm not. But in those days you were, all kinds of people stood out, for whatever reason."

One day, the legendary Hilda Chester shattered the silence of a near-empty Ebbets Field by bellowing, "Vin Scully, I love you!!"

VIN SCULLY: "And then her payoff line was, 'Look at me when I'm talking to you!' I mean, geeez! I've got my head down and everything. But that's the way it was. It was special, it really was."

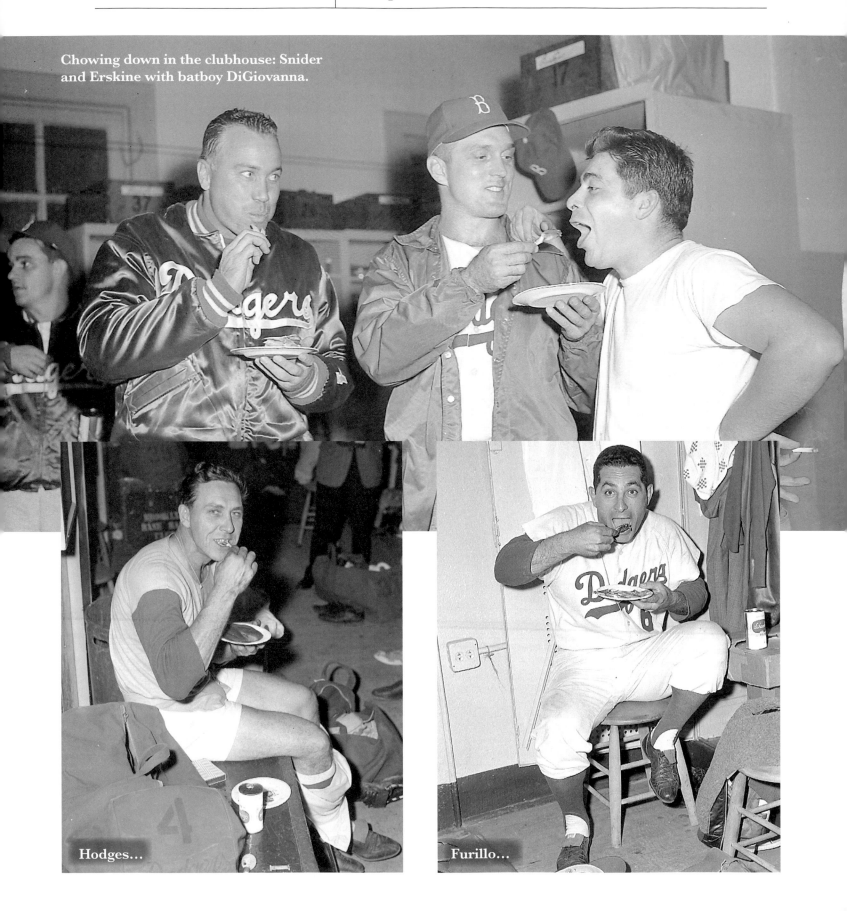

Chowing down in the clubhouse: Snider and Erskine with batboy DiGiovanna.

Hodges...

Furillo...

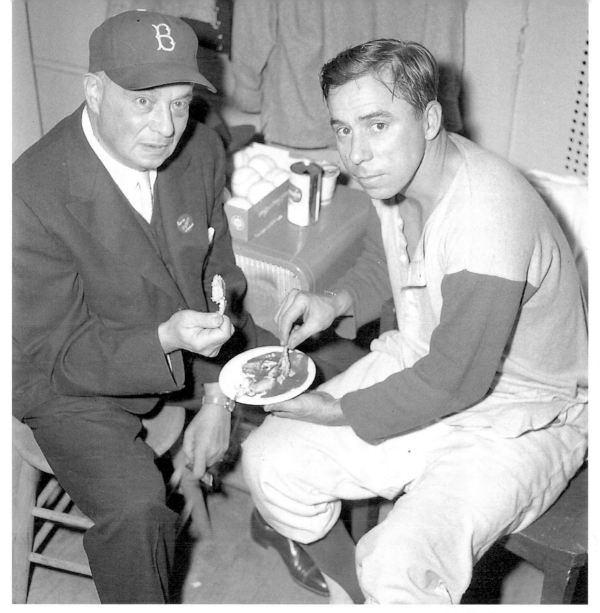

...and In the Captain's Corner, Reese shares a plate with Dodgers director Sylvan Oestreicher (who's wearing the blue "Keep the Dodgers in Brooklyn" button that became standard issue during the 1957 season).

CARL ERSKINE: "Charlie Dressen, when he was manager, used to have crab fingers shipped up from Vero Beach, and we used to have a lot of those in the clubhouse. I don't remember having shrimp so much as we had crab fingers."

DUKE SNIDER: "We would occasionally special order crab fingers from Florida, down from Vero Beach, and that's probably what this is. We'd have them fly them up, and we'd eat after the game in the clubhouse. I'm pretty sure it's crab fingers here."

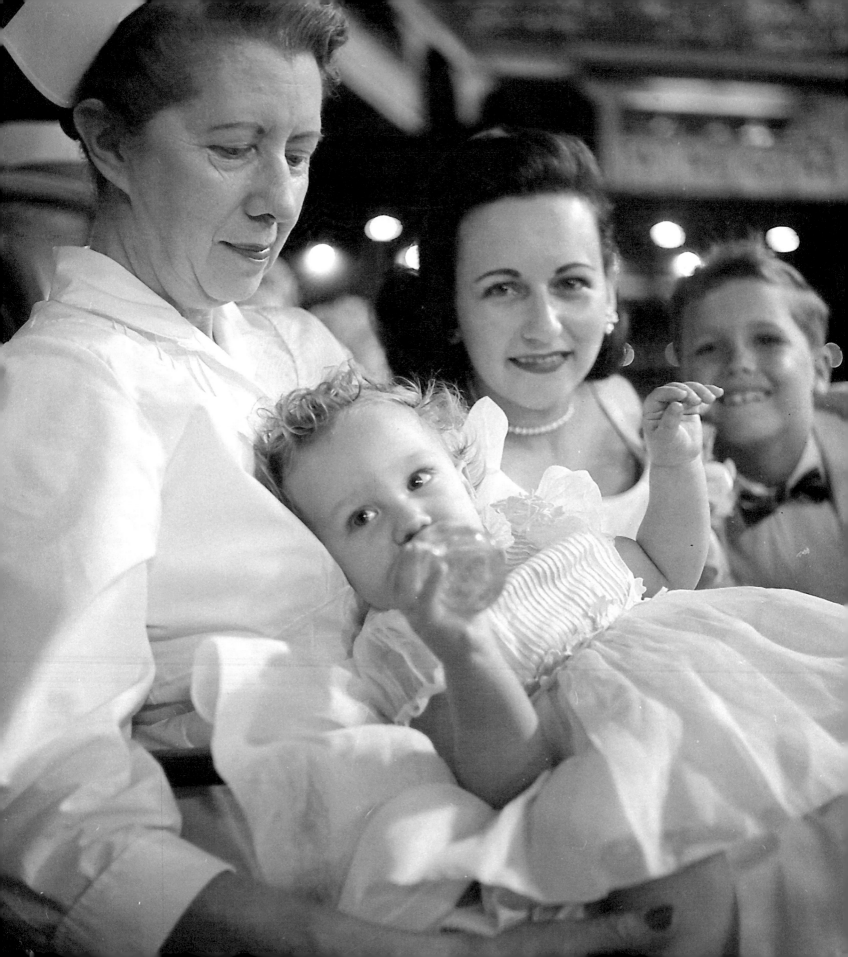

The young and growing Hodges family, up close and from overhead.

JOAN HODGES: "When my Cindy was born, the team was in Philadelphia. Gil was coming home right after the game. She was born on a Sunday, August 19, 1956. They had just taken me back to my room; I had been sedated because I had a high-risk delivery. My doctor had the radio on in my room; of course he was a die-hard Gil Hodges fan. And that's how I knew that I had had the baby, and what it was, because I heard Vin Scully say, 'And that home run was for Cynthia Elena Hodges, born at 12 noon today!' I was still woozy, still coming out of it, and I opened my eyes and I heard Vin Scully say that…and went back to sleep!

"The president of the Gil Hodges Fan Club was Jo Anne Duffy, the young woman that you see here standing in front of the nurse, standing in the aisle. That's Jo Anne Duffy, who I heard from not too long ago. She was and still is a die-hard, devoted Gil Hodges fan. I only had the three children at that time, Barbara wasn't born yet. The nurse is holding Cynthia, and that's Gilly and Irene next to us."

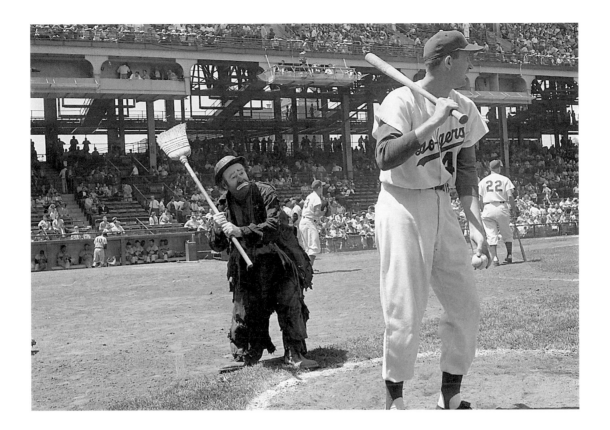

For the final season in Brooklyn, the Dodgers hired famed circus clown Emmett Kelly to, as a press release put it, "relieve tension at Ebbets Field." Kelly's mute "Weary Willie," the living personification of the "Bum" character created by artist Willard Mullin, performed on the field prior to most home games…whether begging for mercy from the umpires or shadowing a fungo-hitting Don Bessent.

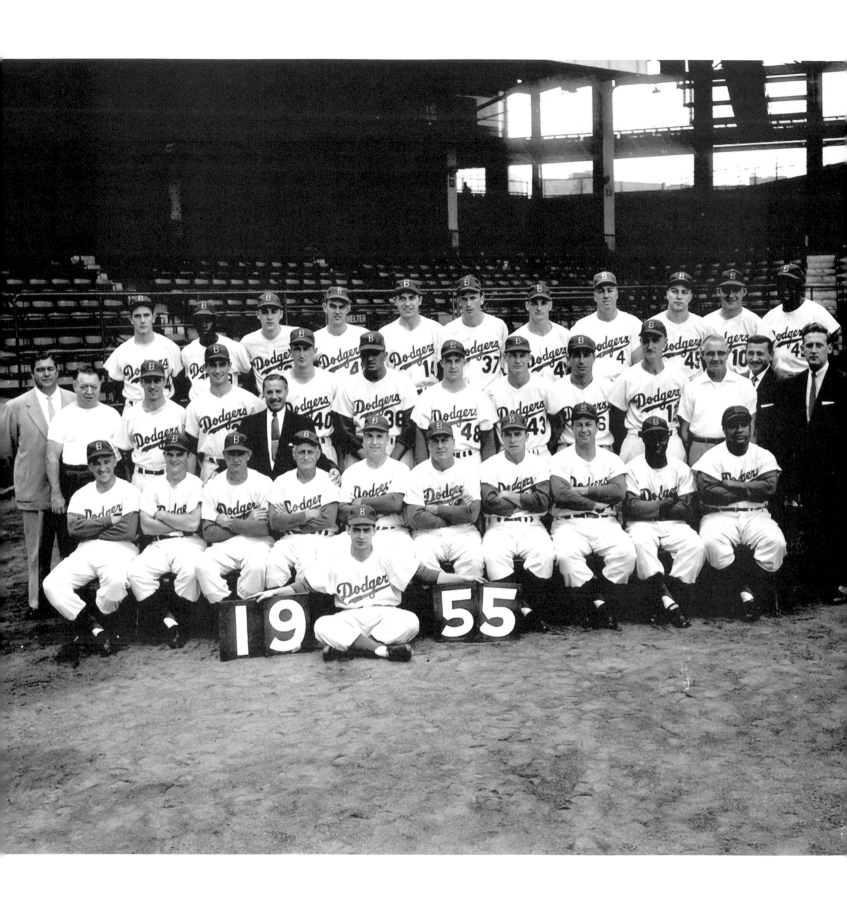

1955

'55

It happened, finally, in 1955.

After all the anguish, all the losses, all the heartbreak. After losing to the Yankees five times in the World Series, dating back to '41…after losing to the Phillies on the last day in '50 and to the Giants on the last day in '51…after watching someone else, always someone else, go home with a championship every October.

But in '55…

The Dodgers ripped off 10 straight wins to open the season, won a stunning 22 of their first 24 games. They made a mockery of the National League race, winning the pennant by 13½ games. But the World Series followed a familiar script, as the Dodgers dropped the first two games at Yankee Stadium.

Back at Ebbets Field, a brash youngster named Johnny Podres went all the way to win Game 3. Campanella, Snider, and Hodges homered to win Game 4 for reliever Clem Labine. Snider homered twice in Game 5 to back the stalwart

There were several versions of the "official" Dodgers world championship team photo, which Barney took at Ebbets Field on September 17, 1955, more than a week after the team had clinched the National League pennant. While the player lineup remained unchanged, some versions included statistician Allan Roth and TV host Happy Felton. Roth and Felton are missing here, but broadcasters Al Helfer, Andre Baruch, and Vin Scully (who are omitted from other versions) are included.

1955 World Champion Brooklyn Dodgers: Front row seated (left to right): George Shuba, Don Zimmer, coach Joe Becker, coach Jake Pitler, manager Walter Alston, coach Billy Herman, captain Pee Wee Reese, Dixie Howell, Sandy Amoros, Roy Campanella. Middle row: announcer Al Helfer, clubhouse manager John Griffin, Carl Erskine, Sandy Koufax, traveling secretary Lee Scott, Roger Craig, Don Newcombe, Karl Spooner, Don Hoak, Carl Furillo, Frank Kellert, trainer Harold "Doc" Wendler, announcer Andre Baruch, announcer Vin Scully. Back row: Russ Meyer, Jim Gilliam, Billy Loes, Clem Labine, Gil Hodges, Ed Roebuck, Don Bessent, Duke Snider, Johnny Podres, Rube Walker, Jackie Robinson. Seated in front: batboy Charlie DiGiovanna.

pitching of rookie Roger Craig, a 5–3 winner. However, just one win away, the Dodgers fell to the Yankees 5–1 in Game 6 at Yankee Stadium.

That left it up to Podres in Game 7. Hodges drove in two runs, one in the fourth inning with a single and another in the sixth with a sacrifice fly after manager Walter Alston told two of his biggest guns, Snider and Campanella, to lay down bunts. Podres wriggled out of trouble, especially in the sixth (on Sandy Amoros's famous catch) and again in the eighth (after the Yanks put runners on first and third with one out).

In the ninth, Podres got the Yankees in order, capping an eight-hit gem. Elston Howard made the last out, sending a grounder to Pee Wee Reese, the only man who had been in uniform each and every time the Dodgers had fallen short for the past 15 years. Reese's throw to Hodges may or may not have been in the dirt—they still argue over that in some pockets of Brooklyn—but when it hit Gil's mitt, it was done. Brooklyn had its first, and only, world championship.

Finally.

DON NEWCOMBE: "My dad was a great baseball fan, and he saw this game coming down the way it was. He of course had followed me all those years, and now in '55 it finally looked like we were gonna win. He came down out of his seat, which was up behind the visiting dugout, and came out on the field. I grabbed him, and I said, 'What are you doing here, Pop?' He said, 'I'm out here to see Johnny Podres.' And I said, 'Well, there he is in the middle of the crowd!' And I'm back over here somewhere, I see the top of my head because I'm probably the tallest one in the group. But my dad came in and grabbed Johnny Podres, and then the security people got him to go back into the stands because there were other people coming on the field.

"One thing about my dad was that he used to love to drink his beer. And he'd be walking around Ebbets Field, for instance, when I was pitching and doing well, and going, 'That's my son! That's my son!' But when I got jocked, I couldn't find him to go home. I had to go to the bar to find him across the street, 'C'mon Pop, let's go home!' And he'd be all sad and disheartened because his son that he loved so much—and I loved my dad—got jocked that night. He loved his Dodgers."

The Yankee Stadium clock reads 3:45 PM on Tuesday, October 4, 1955, freezing the greatest single moment in Brooklyn baseball history. To record the Dodgers' first moments as world champions following their Game 7 win, Barney scrambled onto the field and positioned himself in front of the Dodgers dugout, knowing that the pile of players would eventually move toward him.

Two images survive today; in this first, wider shot, Alston (No. 24), Frank Kellert (No. 12), and George Shuba (No. 8) are about to join the mob embracing winning pitcher Johnny Podres. Don Newcombe (in jacket) is at the rear of the pile, not knowing that he and his teammates are about to be joined by an unexpected guest: Newk's father James Newcombe, the man in the gray suit at far left.

As the mob scene intensifies and moves toward the dugout, the only face completely visible—appropriately—is Podres's (left side). Russ Meyer (No. 34) is at far left, in front of Sandy Koufax and Ed Roebuck (obscured). Stadium manager Jim Thomson, helping to get Podres off the field, is at the pitcher's left.

JOHNNY PODRES: "Oh, yeah. I'm right in the crowd, that's right. That was it. I didn't know if I was going to get killed or not! That was something, that was great."

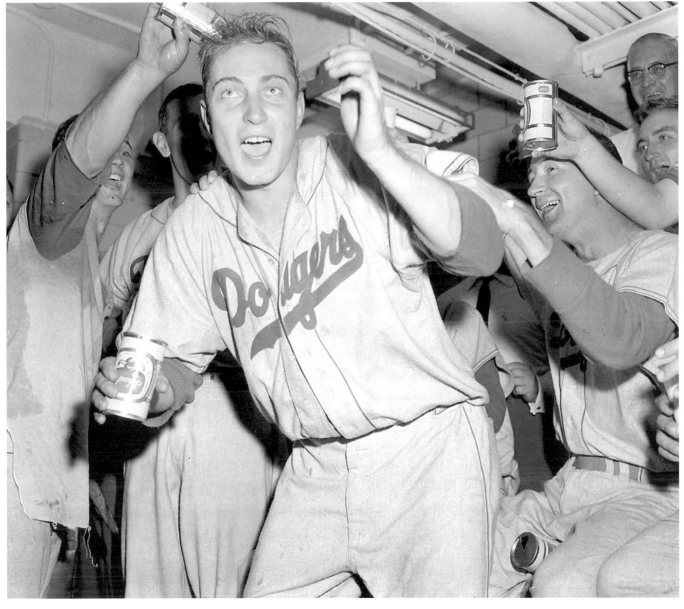

Finally inside the clubhouse, Podres gets doused in the sponsor's (Schaefer) beer.

BUZZIE BAVASI: "Jack Lescoulie wanted John on *The Today Show* (the next morning) and wanted John to drive into New York. I said that John isn't in any shape to go, Jack told me he had a beautiful blonde assistant who'd get in the cab with him, and that was all John needed."

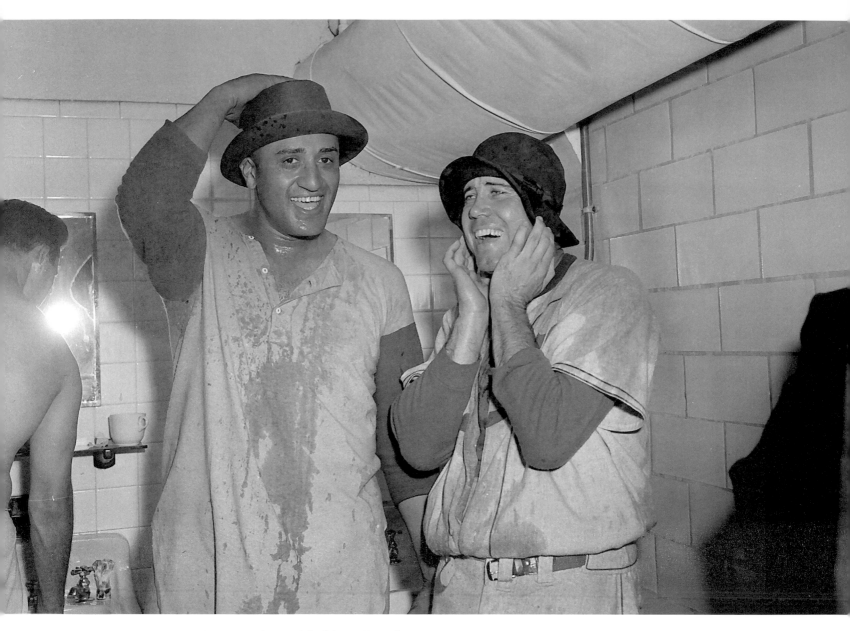

Newcombe and Snider all smiles, as Newk made good on a promise issued a few weeks earlier at the pennant clinching.

DON NEWCOMBE: "We finally won the game [the clincher in Milwaukee on September 8], and I'd gone in and taken a shower and put my street clothes on. I always took care of my street clothes, I did then and I still do. Duke's locker was next to mine, and they all started celebrating and spraying and drinking beer and champagne and stuff like that. Duke came over and was going to pour some on me, and I said, 'Duke, if you pour that on me I'm gonna drop you. Don't do that!' And we had an argument about it, and then went on about our business. I was pissed off. I paid a lot of money and worked hard for my money, and I'm not going to have anybody pouring anything on me. We'll get the chance, I hope, in the World Series. I left the clubhouse when they were in there doing what they were doing, and got on the team bus."

DUKE SNIDER: "Actually, at Mader's Restaurant, I poured champagne in his hat, and he was a little upset about that. Then when we won [the Series], we both got each other's hats, poured beer in the hats, and put them on. So here, I've got his hat on and he's got my hat on."

DON NEWCOMBE: "Then when we won the Series, I said, 'Okay, Duke. I'm going to give you a chance. Pour all you want.' And our clubhouse custodian, John Griffin, had those derbies. He gave us the hats and we started pouring beer and champagne on one another. And we made friends again; we had argued about it before. See, here I've kept my sweatshirt on with the derbies and we drowned each other. We just had a hilarious time."

Bavasi and Campy, toasted by James Newcombe (left).

DON NEWCOMBE: "That's my dad, and you see what he has in his hand, don't you? He's got his beer. Listen, he loved Roy and Roy loved him. I'm surprised he doesn't have his Dodger cap on here, because he loved us so much."

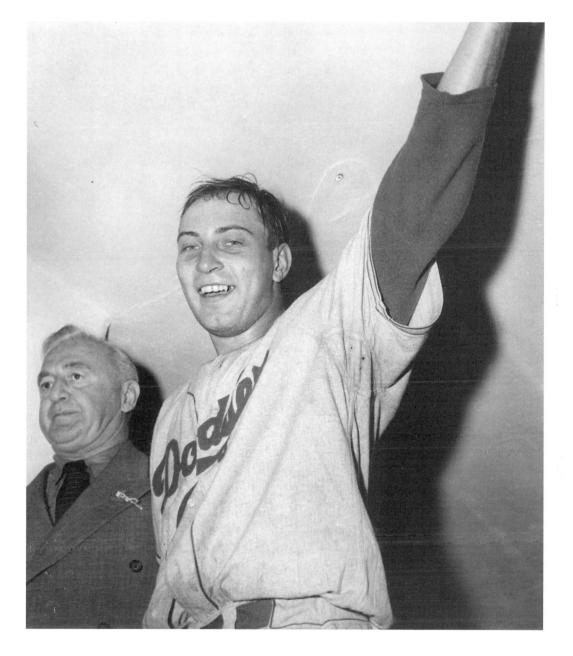

Podres, arm upraised, readies for a post–Game 7 interview with Frankie Frisch on NBC.

JOHNNY PODRES: "Frank got me right after the game. I don't know if I was the first guy he talked to, but I know I was with him. I have no idea what he asked me. Probably the same old stuff, you know, 'How does it feel to beat the Yankees?' Well, hell, how did it feel for the Brooklyn Dodgers to win their first World Series ever?"

Moments after the clinching victory, the Dodgers wives celebrate in the clubhouse tunnel at Yankee Stadium...a photo that was taken several hours later than originally planned.

JOAN HODGES: "Rachel Robinson and Lela Alston are in it, Roger Craig's wife is in it. Billy Herman's wife, Hazel. Millie Walker's there.

"[The photographers] wanted to take a picture before the game. Yes, *before* the game. They wanted to take a picture of us cheering, and they wanted to take a picture of us broken-hearted. And of course, having my temperament, I said, 'We do not do that! We will not take a picture, you know, a sorrowful picture. No, no, no. You wait until after the game and we'll be only too happy to do it.' And I'm trying to think of who I was with when I said it, but I told them I would not be a part of that picture. I told Lela Alston, 'Lela, please don't do anything like that. I'm Catholic and I'm extremely superstitious when it comes to baseball.'"

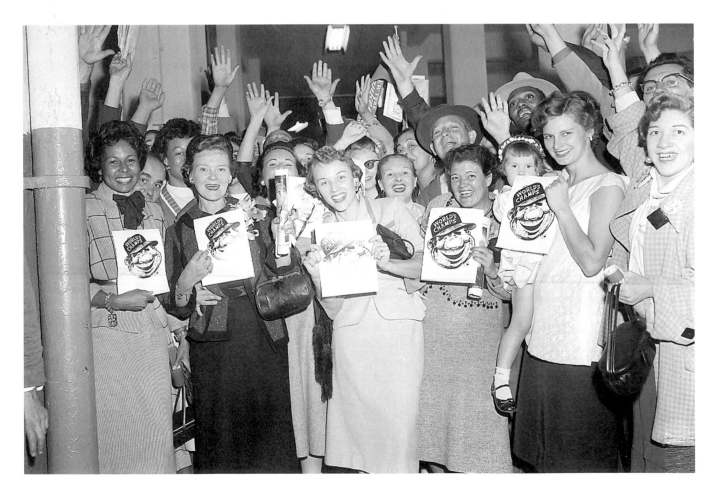

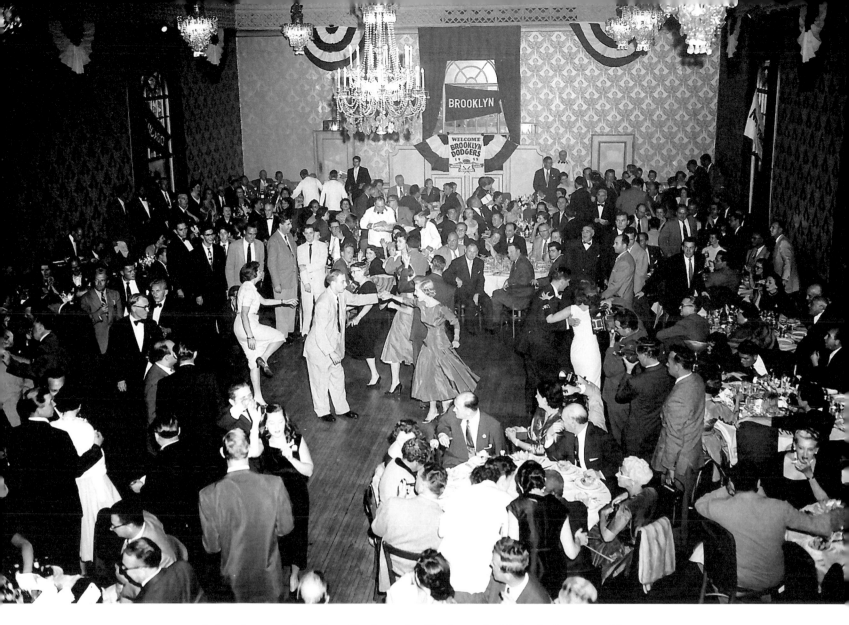

A few hours after the clincher, the Dodgers held their first world championship victory party at Brooklyn's Hotel Bossert, and the only press photographer admitted into the hall was Barney. Here, Podres is in the middle of the floor, dancing with...

JOHNNY PODRES: "I was dancing with Ann Thompson, Fresco's daughter. There were a few others [I danced with], though."

VIN SCULLY: "Ann Thompson, who was Fresco's daughter, was totally different [from Terry O'Malley]. They were both the same age. Terry was quiet, very shy, very aware, very intelligent. Ann was like skyrockets, you know. Totally different. She was like Fresco, who was a wiseacre."

At the victory party at the Bossert (clockwise from bottom): Manager Alston, Kay O'Malley, Buzzie and Evit Bavasi, Billy and Hazel Herman, Walter O'Malley, and Lela Alston.

A kiss for Terry O'Malley—Walter and Kay's daughter—from announcer Vin Scully.

VIN SCULLY: "Ah, yes. The O'Malley family had a tremendous influence on me. My father had died when I was young, and my stepfather was wonderful. But as far as counseling was concerned, Walter O'Malley was like another father, and Terry was like a sister, and Peter's like a brother, to this day. We've always been close. Terry's a saint, one of the all-time greats. She lost her husband recently [in June 2006], but with 21 grandchildren, she's got enough to keep her busy. Oh, sure. That was a very memorable night. That'd be a great picture for me to have, just personally."

O'Malley mans the phone booth while Carl Erskine and Duke Snider wait their turns.

CARL ERSKINE: "You know what I think this is? I think this is a staged photo of Walter O'Malley calling in to make arrangements for the victory party after we won the Series. That's just my take on it. It's kind of a staged call. That may have been set to be run in the papers as 'O'Malley arranging for the victory party.' That's just my take."

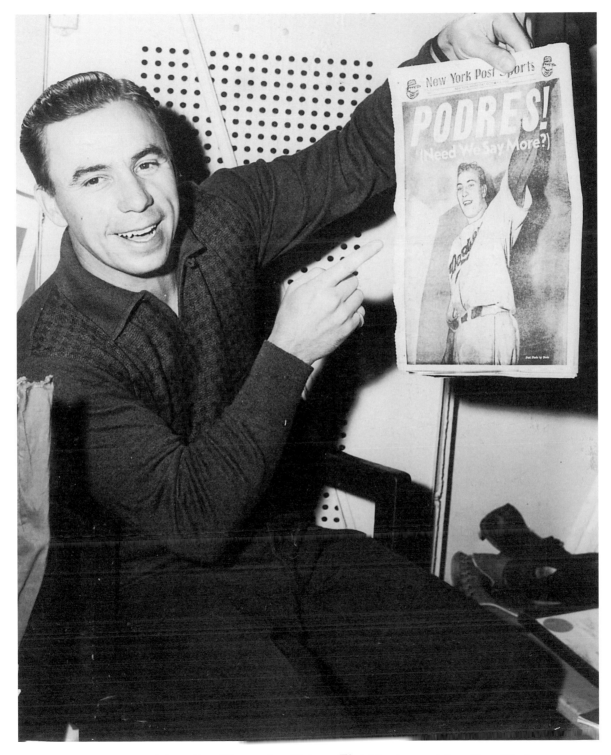

The Day After: Pee Wee at his Ebbets Field locker, with a *New York Post* back page that said it all.

EIGHT

Farewell

Two years after their greatest triumph, the Brooklyn Dodgers were gone.

Walter O'Malley's dream of a privately financed, state-of-the-art ballpark would be conceived in Brooklyn but realized in Los Angeles. The years 1956–57 would be marked with political infighting in New York and grand overtures made from the West Coast. There was talk of the outmoded state of Ebbets Field, of the Dodgers' crying need for a new facility, of a domed stadium at Atlantic and Flatbush Avenues, of perhaps a city-owned stadium in Flushing, Queens. Ultimately, when faced with the reality that he would be a tenant and not an owner of any new stadium in New York, O'Malley took the Dodgers west.

Tuesday night, September 24, 1957, marked the Dodgers' final game at Ebbets Field. Although the move had not been formally announced (and wouldn't be until October 8), an air of finality hung over the old ballpark, where 6,702 fans saw Danny McDevitt scatter five hits in a 2–0 blanking of the Pittsburgh Pirates. With a reporter's instinct, Barney extensively recorded the evening's activities both on and off the field, producing a series of images that are every bit as haunting as they are historic.

Ebbets Field, May 1960.

RALPH BRANCA: "I remember it was a cold day [when the demolition began], and they had the big crane and the big ball. We all gathered there and the ball came crushing down on the roof of the visiting dugout. To me, it was like a knife stuck in my heart to see that happen."

CARL ERSKINE: "I was there the day they dropped the ball, Branca was there and Campy was there, and Tommy Holmes. They had painted this big iron ball like a baseball, white with red stitches on it. And they had me pretending I was throwing it or something. When the ceremony was over, they swung that ball over the visitors' dugout and dropped it. And I'm telling you, I just got sick, as much as I hated that dugout. I left, I didn't want to see any more of it."

Three years later, after Ebbets Field had been turned over to international soccer, college baseball, and demolition derbies, Barney Stein returned to the place he loved best to record its final moments. At the public auction in early 1960 and then through the subsequent demolition, Barney and his camera covered the old territory one more time: the field, the stands, the clubhouse, the fans (those few who showed up at the very end). For Barney and for a borough, a piece of their soul had been lost forever.

This extraordinary photograph was taken on March 6, 1957, and provides one of the first tangible links between the Brooklyn Dodgers and their future home. An eight-man delegation from Los Angeles spent a day with the Dodgers in spring training, extolling the virtues of their city. Here, team president Walter O'Malley (second from left), Duke Snider (center), and mascot Emmett Kelly pose with Los Angeles mayor Norris Poulson (second from right) and county supervisor Kenneth Hahn (far left). Kelly's expression speaks for an entire borough.

DUKE SNIDER: "They came down during spring training, and the rumors were starting then that L.A. was starting to woo Mr. O'Malley. So they had this picture taken, with the gloomy Emmett Kelly. And me, being from Los Angeles and born in Los Angeles, they put me in the photo. I remember that occasion; this was right outside of our clubhouse in Vero Beach. When they came to Vero Beach, that's when the rumors really started floating around."

BUZZIE BAVASI: "That picture was taken in Vero Beach. The woman who should get all the credit in the world for bringing us out there was [councilwoman] Roz Wyman. Without Roz Wyman, we might have stayed in Brooklyn. And she arranged this trip."

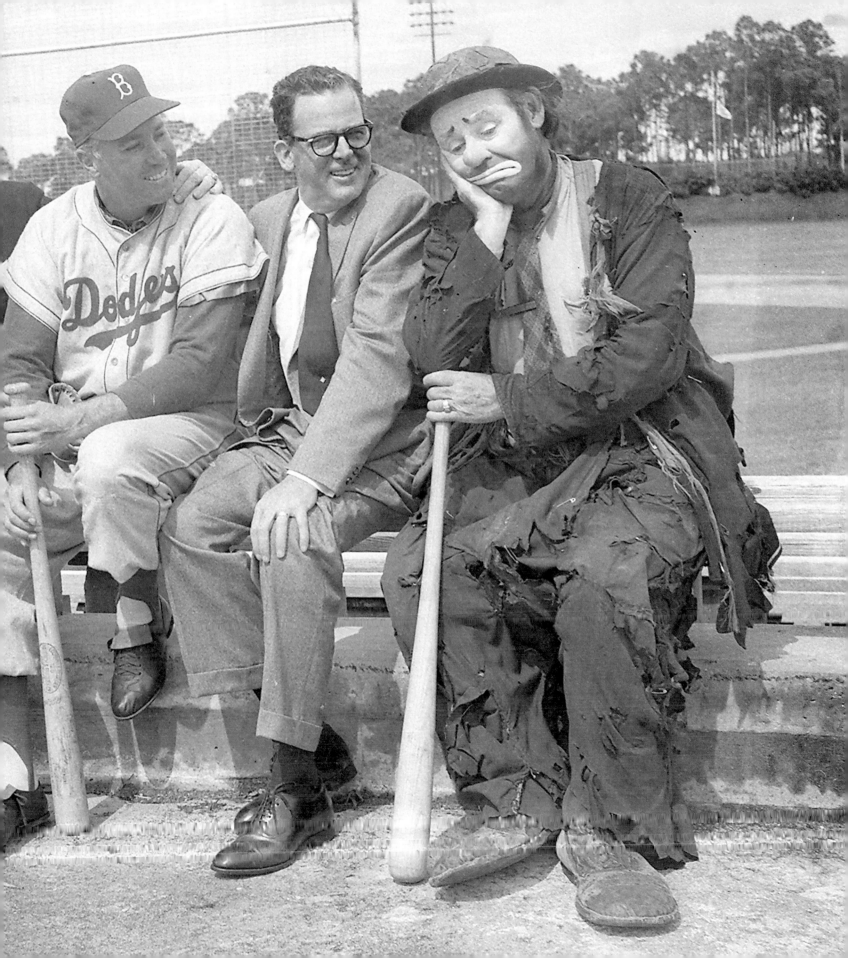

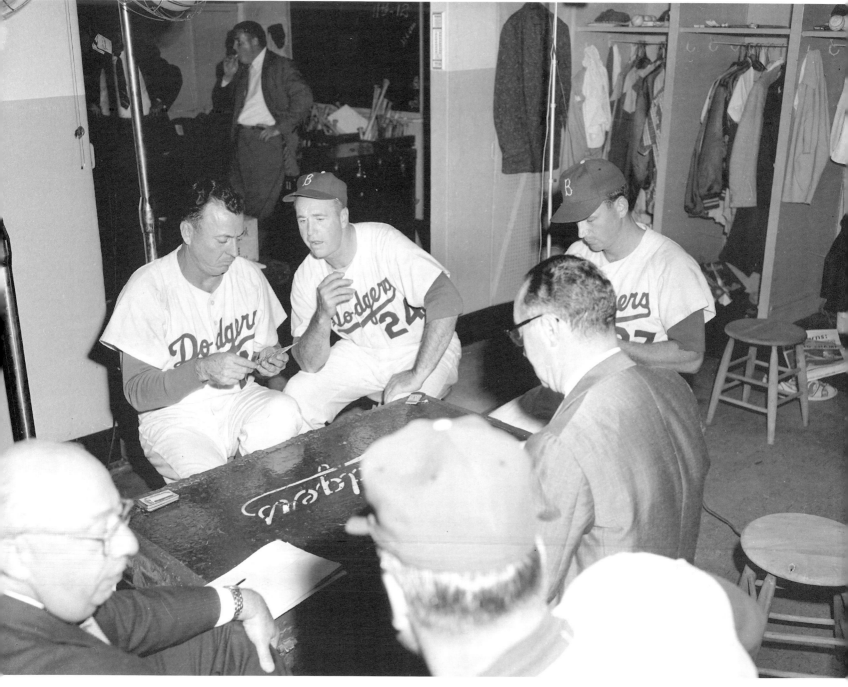

In the clubhouse on the final day, September 24, 1957:
Alston kibbitzes over a bit of cardplay between coach Billy Herman
(left) and Eddie Roebuck (right).

Alston with Coach Jake Pitler (left).

Pee Wee Reese (right, in profile) chats with Dodgers business manager Harold Parrott (in suit). Rube Walker and Gil Hodges sit at their lockers behind Parrott. Notice how Reese's locker—in deference to his status as team captain—is turned sideways while the other lockers face the center of the room. Also note the players' numbered equipment bags, already packed for the final road trip to Philadelphia.

Duke Snider (No. 4) sits on an equipment trunk near his locker. Also in the shot are Coach Pitler (No. 31), Ed Roebuck (on stool, facing into his locker), and Dodgers official Matt Burns (in suit). Beyond them is the main entranceway to the clubhouse, and the coaches' room (Billy Herman's No. 22 equipment box is visible…and note the good-luck horseshoe on the door frame).

DUKE SNIDER: "My locker is around the corner and to the left just a little bit from where I'm sitting. I don't know what I'm doing there. Where Jake Pitler and the other gentleman are—is that Matt Burns?—my locker is just to the left of that. The coaches' locker room is where that doorway is. And where the scale is, just to the left of that is the trainer's room."

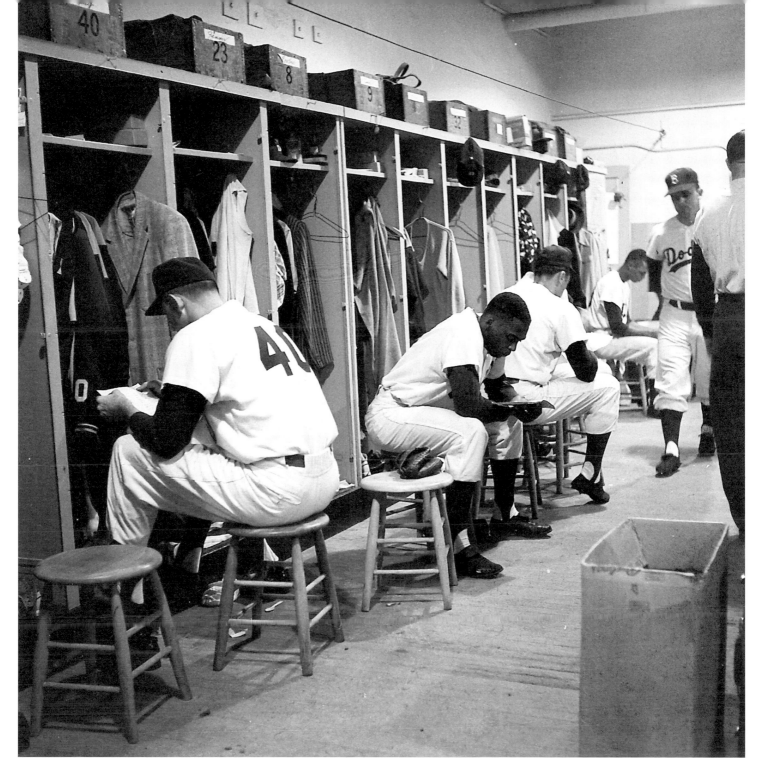

Roger Craig (No. 40), rookie Johnny Roseboro, Gino Cimoli, and Charlie Neal (far corner) sit in front of their lockers before the last game, while Don Zimmer walks toward his cubicle (between Craig's and Roseboro's).

Carl Furillo (No. 6) obliges final-night autograph seekers, while Don Zimmer (No. 23) sits on the dugout steps. Also in the shot are Jim Gilliam (left of Furillo), Coach Pitler (entering the dugout, center), and Campanella (seated behind post).

A shot of the Dodgers dugout midway through the final game. Manager Alston (No. 24, without jacket) sits just off the center tunnel. Tex Rickards, Ebbets Field's legendary, malaprop-prone public address announcer, sits in the small alcove just off to the right of the dugout, behind batboy Eddie Lehan.

Game over: the Dodgers surround winning pitcher Danny McDevitt and head off the field. Their next home game will be seven months later...and 3,000 miles to the west.

DUKE SNIDER: "I didn't want to play in the game. This was on a Tuesday. Before that, on my last at-bat on Sunday, I hit a home run, and I wanted my last at-bat at Ebbets Field to be that home run. I didn't participate in the game, but I was on the bench watching when we beat Pittsburgh. It was kind of dark that night; the lights didn't seem to be as bright. We all had that feeling, not knowing for sure, but we all had that feeling that was going to be the last game at Ebbets Field."

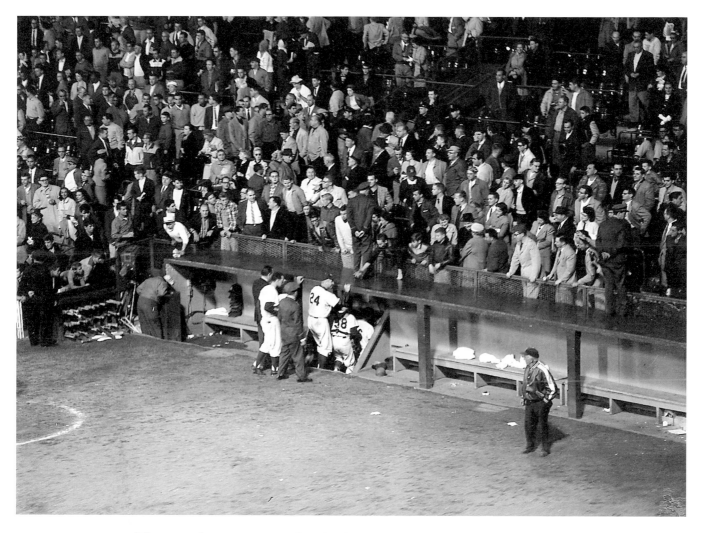

The very last moments for the Dodgers in Brooklyn: Alston (No. 24)
is nearly the last to enter the tunnel to the clubhouse, behind backup
catcher—and Brooklyn native—Joe Pignatano (No. 58), who caught
the game's last four innings.

Gone, forever.

Ebbets Field's final public event was an unusual auction sale on April 24, 1960. Professional auctioneer Saul Leisner presided as flags, signs, equipment, seats, and other items from the doomed ballpark were put up for bid. A month earlier, Leisner made the stunning (by today's standards) announcement that fans could stop by the empty stadium and literally walk away with anything they could carry. There were few takers.

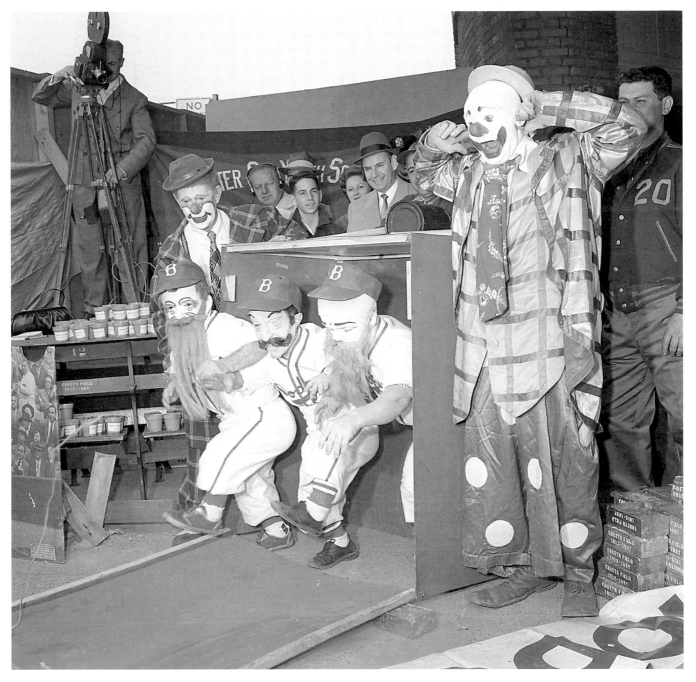

The auction began on a bizarre note when a fake Ebbets Field cornerstone "exploded," upon which a team of dwarf clowns dressed in Dodgers uniforms emerged.

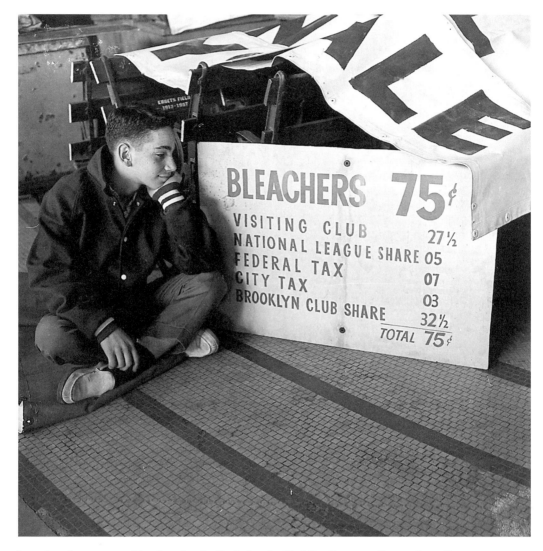

Auction items on display included the individual team flags that flew over the main entrance and the "Schaefer awards" player name signs that hung on the left-field wall and next to the scoreboard. Various team yearbooks were available as well, including that of the 1960 *Los Angeles* Dodgers.

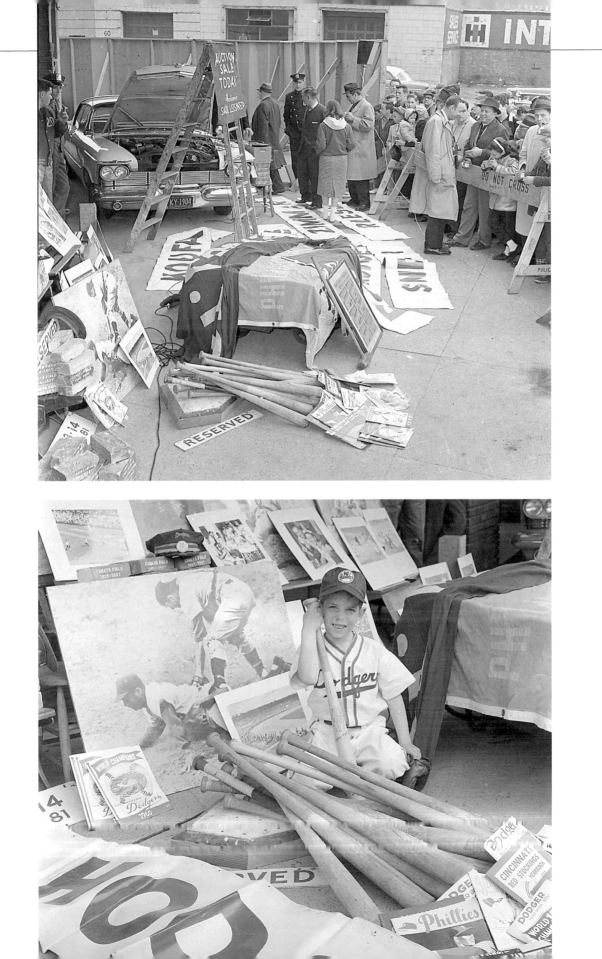

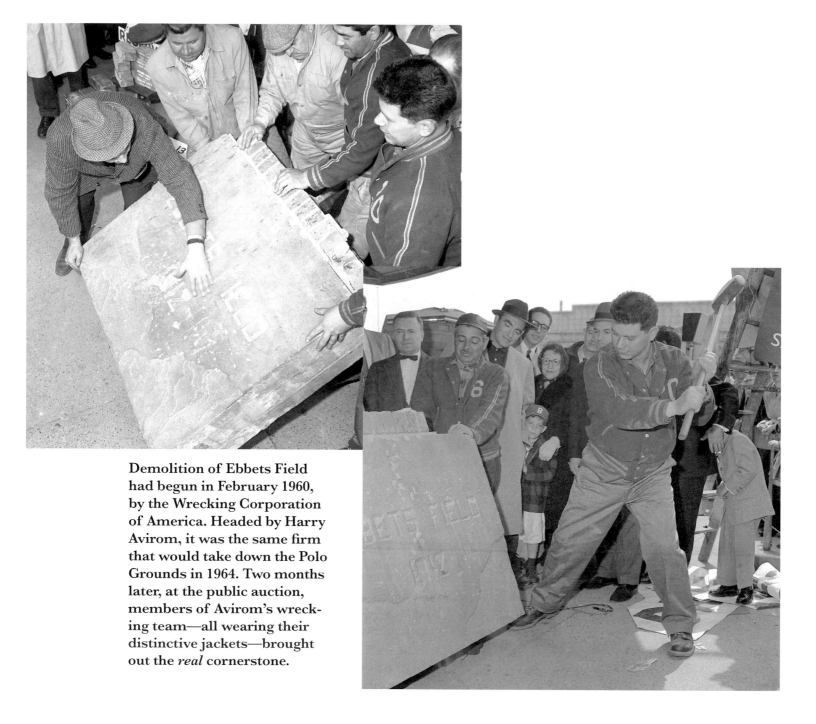

Demolition of Ebbets Field had begun in February 1960, by the Wrecking Corporation of America. Headed by Harry Avirom, it was the same firm that would take down the Polo Grounds in 1964. Two months later, at the public auction, members of Avirom's wrecking team—all wearing their distinctive jackets—brought out the *real* cornerstone.

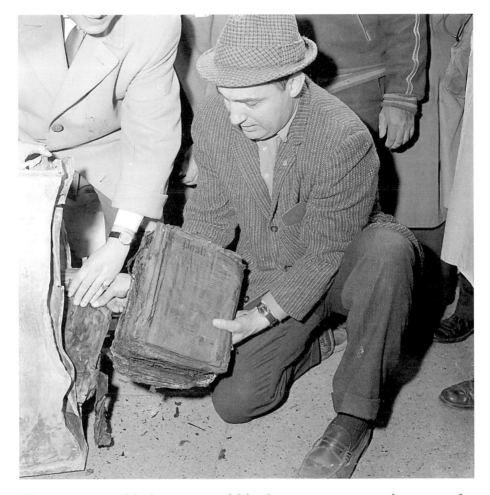

There was an added treasure within the cornerstone: a time capsule
that dated back to 1912, one year before the park opened. An Avirom
crewman yielded a sledgehammer, breaking open the cornerstone
and unearthing the time capsule. But its contents—which included
newspapers, coins, photos, and letters from the likes of President
Taft and Admiral Peary—had fallen victim to the elements after
nearly five decades. (Ironically, a similar time capsule of 1962 vin-
tage rests behind the dedication plaque on the top deck of Dodger
Stadium in Los Angeles.) The remaining cornerstone was bought
(for $600) by National League president Warren Giles, who turned it
over to the Baseball Hall of Fame, where it rests today.

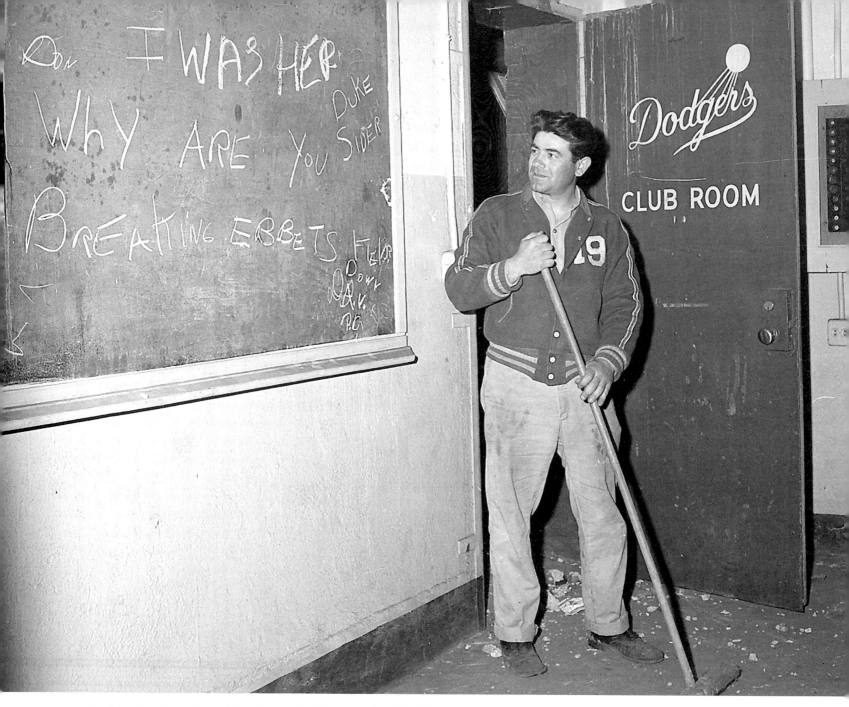

Inside the abandoned Dodgers clubhouse, the blackboard that served as the background for many of Barney's postgame photos (remember "The Bums Dood It" shot in chapter 1?), now carries its last and most poignant message: "Why Are You Breaking Ebbets Field?" An Avirom worker can only wonder.

CARL ERSKINE: "That big iron door which, when it slammed, sounded like a bomb went off. It just reverberated through the clubhouse. The blackboard was where they always put up the schedule for the day—what time batting practice was, any special events, and so forth. [Equipment manager] John Griffin would write it in chalk on that blackboard. It was used, basically, to keep the day's schedule updated."

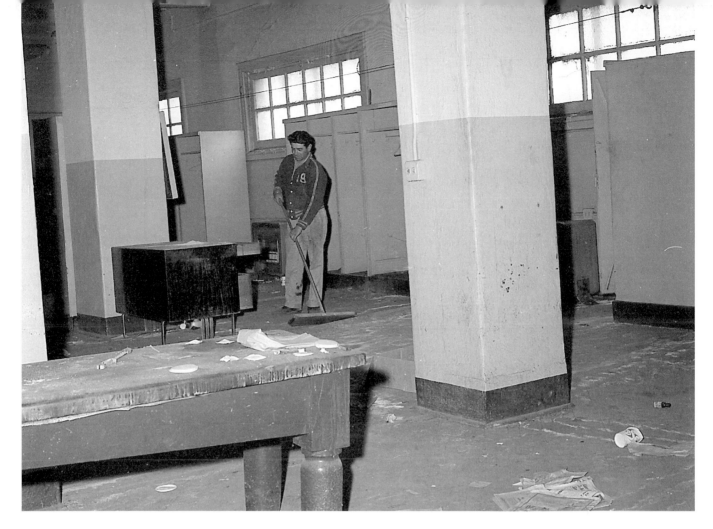

Sweeping up one more time, in a shot taken from the entranceway to the main room of the clubhouse.

CARL ERSKINE: "You see the pillars? Where the desk is there, that was Jackie's locker. The pillar that's closest to us, Duke's locker was on that side. Pee Wee was under the window in the corner. My locker was on the opposite side of that pillar from Jackie. Now, we moved around a little bit, but that's where I ended up my last few years. Before that, I'd had a couple of other locations in the clubhouse.

"John Griffin took care of you if you took care of him. You didn't want to rough up Griff. If you gave him a rough time, he had all kinds of ways to make it unpleasant for you. If you treated Griff fair and you didn't get mad at him, then he was okay. I didn't have any problem with that. Some guys couldn't get along with Griff. But as I began to get better established, I got better lockers. And finally, I was out in King's Row there. Campy, me, Jackie, and Duke, I think, had our lockers on the pillars. You know, there are very few photos of the clubhouse where you can see all the lockers."

DUKE SNIDER: "Pee Wee's locker is to the far right there, and mine was by that pillar, to the left of the guy with the broom in his hand. My locker was right in that area. [Originally] I was back at the far right near where you go into the shower, [and] when that locker became available out front, I asked John Griffin if I could have that locker and he said yes. I don't remember who had it before. I took that locker because it was a little easier to get to and a little more roomy, because you were kind of crowded together along that wall."

The Dodgers locker room breathes its last, but if you close your eyes…

DON NEWCOMBE: "Pee Wee was in the corner, we called that the Captain's Corner [right side of photo]. My locker was down here [on the left side]. That's the entrance to the shower room [directly behind the sweeper]. This is Furillo's locker over here [to the far left], Roy was here, and Jackie was here [left side]. Snider was down this way toward the door [farther left, out of frame]. We had another guy I remember earlier, Marvin Rackley, he was here on the right. Gil was here on the right side, too. It wasn't a very big locker room. The restrooms are back here [doorway behind the sweeper]. When you went through that door, you'd turn left to the showers and right to the commodes and the sinks. The manager's office was through a door here on the left [out of frame]; you'd have to turn a corner to get to the manager's office."

CARL ERSKINE: "Griff always had stuff going. He had a sign over the urinals, 'Players with short bats, please step up to the plate.' And then another one said, 'Please don't throw gum in the urinals, it makes it taste bad.'

"Now, to the left of this picture, and you can't really see it, is a very famous door. It's back in the left corner deep in the clubhouse. And that's the door between the visitors clubhouse and the Dodgers clubhouse. That's the door that was never locked; it was a conventional wooden door. And guys would come from visiting teams who had been traded or whatever, they'd open that door and come in and see some of their friends. It was just an open door. It wasn't used a lot, but occasionally a guy from another team who had played for the Dodgers would want to see some of the guys, and he'd come in.

"Well, we beat the Giants three straight in '51, in August. And Dressen wanted some of the guys to go back and sing through the door, 'The Giants Are Dead,' but some of us wouldn't do it, I wouldn't do it. Dressen and I don't know who else went back there and sung. The Giants were really down, they were $12\frac{1}{2}$ games out at that time. And Leo was so incensed that he, of all things, complained to Warren Giles, the league president. And they bricked that door up, and it was bricked shut from '51 on until we moved."

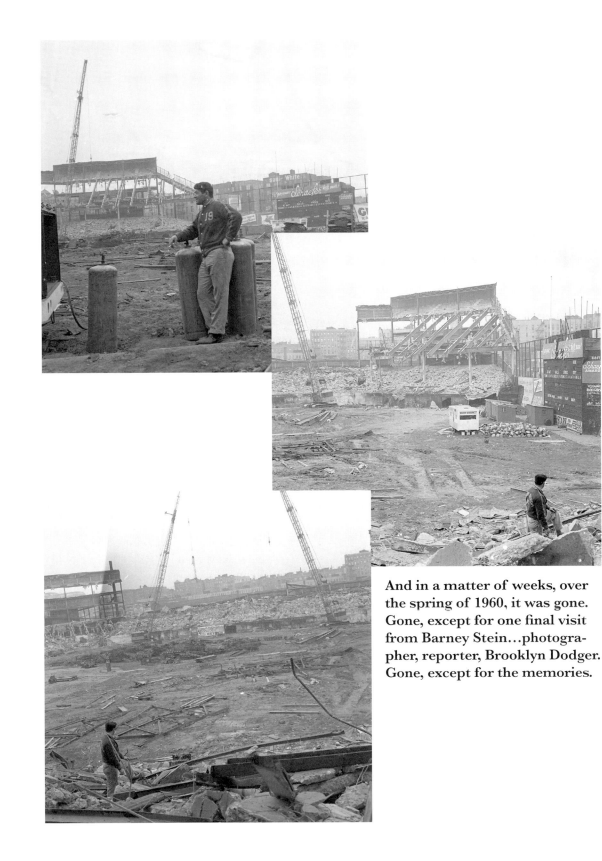

And in a matter of weeks, over the spring of 1960, it was gone. Gone, except for one final visit from Barney Stein…photographer, reporter, Brooklyn Dodger. Gone, except for the memories.

ACKNOWLEDGMENTS

My husband, Steve, my renaissance man who takes life to a higher level, whose love, inspiration, well-taken advice, creativity, moral and financial support, and editorial assistance made this book possible.

My sister, Harriet, and her husband, Les, for their editorial advice.

Thanks also to Stephen Bennington, my London webmaster, with whom I sat side-by-side for two years digitizing and archiving the collection, and who continues to come to my assistance; Roy Engelbrecht, former president of the Pittsburgh Chapter of the American Society of Media Photographers (ASMP), who with Armand Engelbrecht provided the technical assistance and guidance to set up my computer workshop.

To Rob Mitrick Jr., writer and graphic artist, who helped me lose my fear of my first Mac; to sportscaster George Michael for his assistance in identifying players in many action shots and for referring me to the indefatigable Frank Ceresi.

To Thomas J. Smart, former director of exhibitions of the Frick Art & Historical Center, Pittsburgh, for his ability to see the details and excitement in the photos from a non-baseball lover's point of view; to Don Wershba for his transfer of Barney's 1967 radio interview to CD; to our agent John Monteleone for his belief in the project and perseverance in getting the book published; to Duane Rieder, an outstanding photographer who shared his contacts and knowledge; to the Naples chapter of the Society for American Baseball Research, and to Mel Poplock for their cheering section.

To Jerry King, president of the Naples Mac Users group, for handling technical problems beyond my capability; to Dennis DiGiacomo, my computer guru who enables me to communicate with my colleague, my publisher, and the world; to Gail A. Thoen, Ph.D., who suggested I connect some missing personal links to my writing; Mark Altschuler, Ph.D., who early on made me see the value of pursuing this project; Charlotte McDaniel, Ph.D., who led me to Russell Orkin, counselor at law of the Webb Law Firm; to Rose Mary Everett, who led me to Jeff M. Novatt of Cheffy Passidomo, Wilson and Johnson, LLC; to Jim Roselle of WTJN Radio in Jamestown, New York, who teamed with Russell E. Diethrick Jr., a member of the Babe Ruth League International Board of Directors, for their prepublication interview at the studios of the Chautauqua Institution.

To the heroes of my childhood: Carl Erskine, Don Newcombe, Johnny Podres, Ralph Branca, Clem Labine, Duke Snider, the dynamic Joan Hodges, Vin Scully, Mark Langill, Billy DeLury, Buzzie Bavasi, and Peter O'Malley for stepping up to the plate to make this journey so special; and to Arty Pomerantz for always being there for Barney and his family. Then there's Dennis, the other "kid" from Brooklyn, my dream colleague, a writer who gets to the heart of things. And to the late Ruth Stein, my mother, Barney's biggest fan and supporter who endured his antics with good humor; and to the great Barney Stein, "the spry little guy with the camera," my dad, who taught me to love baseball and to persevere.

—Bonnie Crosby
Chautauqua, New York
October 31, 2006

Upon completing the text for Barney's *The Rhubarb Patch*, Red Barber began the book's introduction with, "I played one round of golf in 1953, and this book is the reason I didn't get out on the course more frequently."

I know the feeling. I don't play golf, but this book is the reason I didn't get out of the house more frequently over the summer of 2006, and why for months the floor of my home office was strewn with printouts of 50- and 60-year-old photographs.

I had a marvelous time. Barney Stein, a man I had never known or met, became a virtual companion, and uncovering his work became my inspiration. Even more gratifying was the help and support I received from a group of very special people.

My most heartfelt thanks go to the members of the Brooklyn Dodgers family who were so generous with their time and who so freely shared their memories of, and their love for, Barney Stein. To Buzzie Bavasi, Ralph Branca, Carl Erskine, Joan Hodges, Don Newcombe, Johnny Podres, Vin Scully, and Duke Snider...I cannot begin to thank you enough.

From the Dodgers (Los Angeles version), I was blessed with a constant, three-man support team from the moment the project was launched: team historian Mark Langill, special assistant Billy DeLury, and television producer Rob Menschel. Whether it was tracking down a phone number, clearing up a cloudy historical point, or trying to nail down the identity of that last guy in the photo, Mark, Billy, and Rob were there for me every step of the way. None of them was ever too busy to make time for me, and none ever hid when I came stomping down the press box hallway with yet another stack of photos to be ID'd. Rob was also gracious enough to lend some Barney photos from his personal collection to the book. To all three of you, all keepers of the Dodgers flame, the egg creams are on me.

Brent Shyer of O'Malley Seidler Partners, LLC, coordinated Peter O'Malley's involvement in the book. Brent and Peter championed this project from the start and were vital in every aspect, from fact-checking to photo identification. In addition, they allowed me to use several of Barney's photos from the O'Malley family collection. To Brent and Peter, a very special thank you.

Thanks as well to the Dodgers PR staff, to Josh Rawitch, Colin Gunderson, Crystal Fukumoto, and Joe Jareck, who have always made me feel welcome at Chavez Ravine. When you guys saw me working in the pressroom underneath that huge photo of Barney, my location was *not* coincidental! And (since I'm older than all of you) a tip o' the Dodgers cap to my old PR friends Dave Tuttle, Ruth Ruiz, Steve Brener, Mike Williams, John Olguin, Derrick Hall, and Toby Zwikel. And to Ned Colletti, a damn good PR man himself before he saw the light and took up general managing: I'm still waiting for you to sign my Dallas Green book!

Also, extra-special thanks to Rachel Robinson and Sharon Robinson, as well as to Barbara Tribble of the Jackie Robinson Foundation.

I relied on a number of Dodgers-related books to provide vital details and background information. Among them were Buzzie Bavasi's *Off the Record* (Contemporary, 1987), Fresco Thompson's *Every Diamond Doesn't Sparkle* (McKay, 1964), "Unswerving" Irving Rudd's *The Sporting Life* (St. Martin's Press, 1990), Red Barber's *The Broadcasters* (Dial, 1970), Harold Parrott's *The Lords of Baseball* (Praeger, 1976), Neil Sullivan's *The Dodgers Move West* (Oxford, 1987), Bob McGee's *The Greatest Ballpark Ever* (Rivergate, 2005), Stewart Wolpin's *Bums No More* (St. Martin's Press, 1995), Bill Shannon's and George Kalinsky's *The Ballparks* (Hawthorn, 1975), Philip Lowry's *Green Cathedrals* (AG Press, 1986)...and of course, Roger Kahn's iconic *The Boys of Summer* (Harper & Row, 1971) and Barney's own *The Rhubarb Patch* (Simon and Schuster, 1954). Two other key resources were the marvelous websites retrosheet.org and walteromalley.com.

Also lending a hand along the way were Jeff Idelson of the National Baseball Hall of Fame, Ed "Talkin' Baseball" Randall, the indispensable Sally O'Leary of the Pittsburgh Pirates, Charley Steiner, Rick Monday, Boyd Robertson, Ben Platt, John Miley, Marty Appel, Bob Mandt, Arthur Richman, and Jay Horwitz, mentor and friend (Jay, can you believe we're *still* fooling 'em?). Thanks to Triumph Books for taking yet another chance on one of my crazy ideas—to Mitch Rogatz, Tom Bast, Linc Wonham, Scott Rowan, Amy Reagan, and Jessica Paumier. Thanks again to John Monteleone, our undaunted agent, who once again came through just when all seemed lost. And thanks to all my friends at the NBA, the New York Knicks, Fox, and ESPN, who keep me busy (and gainfully employed) between book assignments.

To the memories of Clem Labine and Jack Lang, who, I hope, would have been very proud of this book.

To Bonnie and Steve Crosby, thanks for giving me your unstinting confidence and faith that I would do justice to Barney's memory. I hope I gave you, and Barney, something to be proud of.

And, as always, to Helene, whose plaque in the Hockey Hall of Fame went up in the Great Hall, just a few feet from the Stanley Cup, on that magic day in November 2005. Suffice it to say that she's been in my personal Hall of Fame a lot longer than that.

—Dennis D'Agostino
Huntington Beach, California
March 2, 2007